EVERY CREATURE IN THE JUNGLE

TREMBLED WHEN IT SENSED MY

APPROACH. "LET THEM TREMBLE

AND UNDERSTAND WHO IS THE

MASTER, LORD OF THIS WORLD,"

I THOUGHT WITH PRIDE.

R. K. Narayan
A Tiger for Malgudi

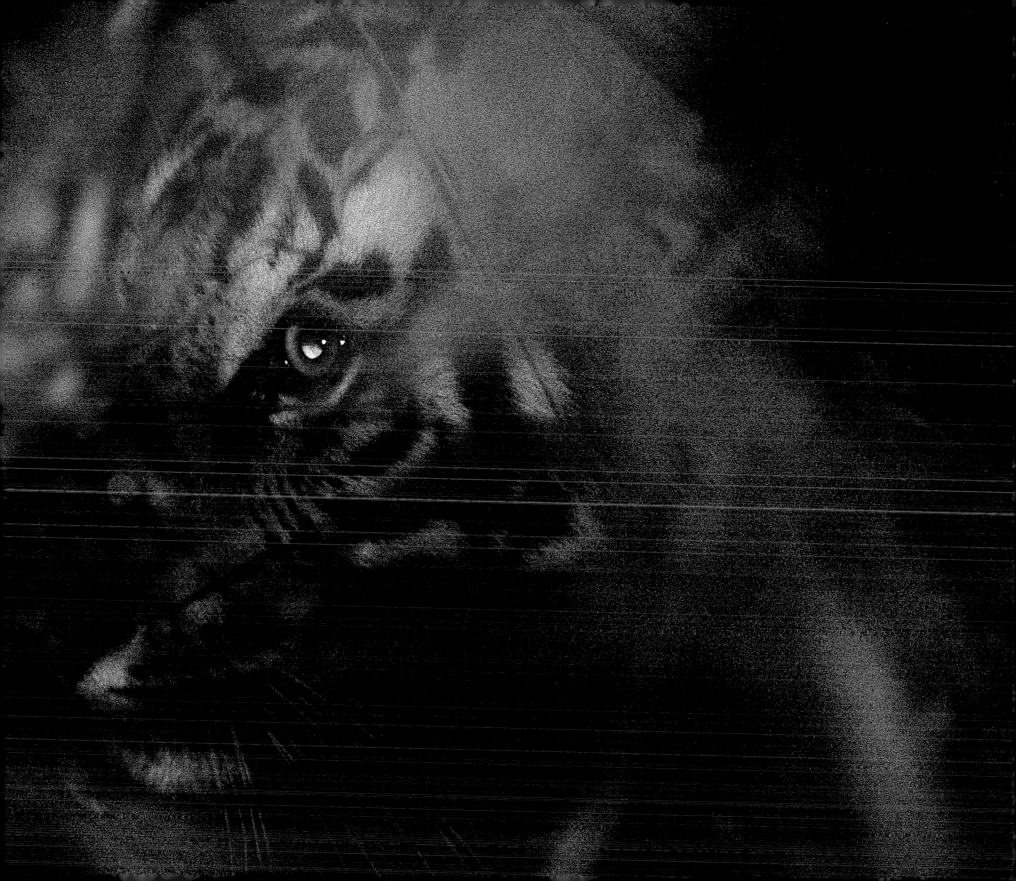

WHILE QUESTING THROUGH

THE JUNGLE, THE TIGER

GLIDES SILENTLY ALONG.

HE SEEMS TO FLOW PAST

ONE LIKE A PHANTOM.

Dunbar Brander

ALWAYS SECRETIVE—

NEVER DEVIOUS

ALWAYS A KILLER—

NEVER A MURDERER

SOLITARY—NEVER ALONE

John Seidensticker

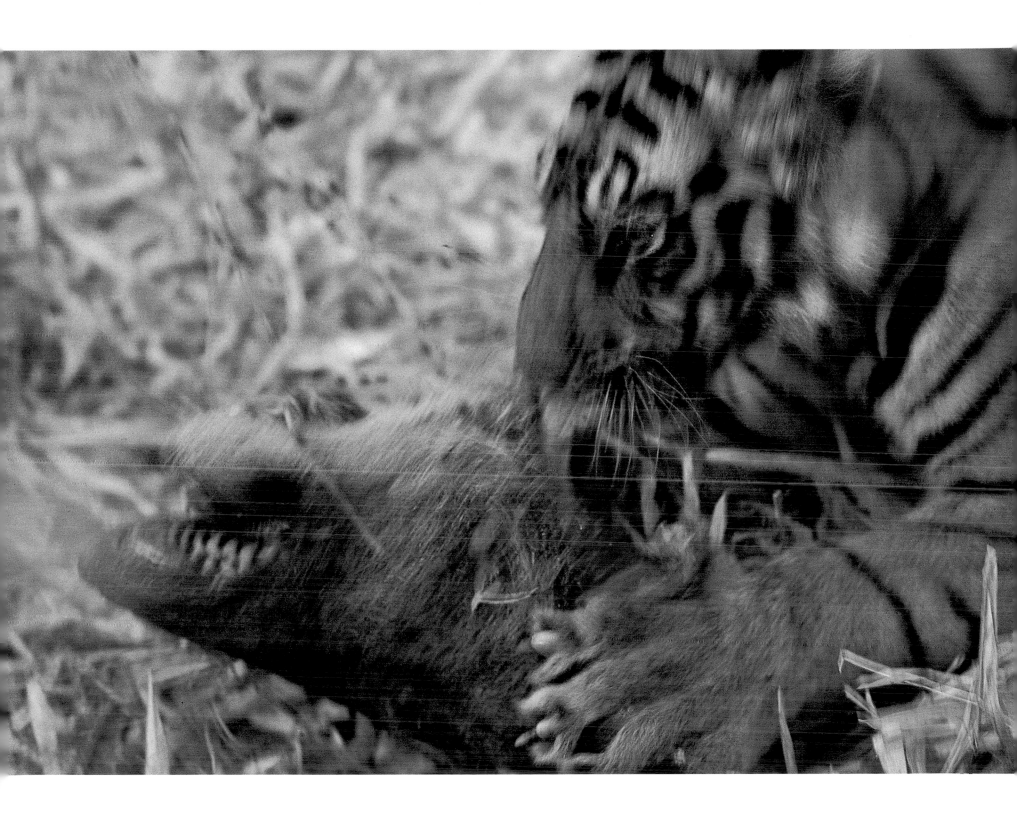

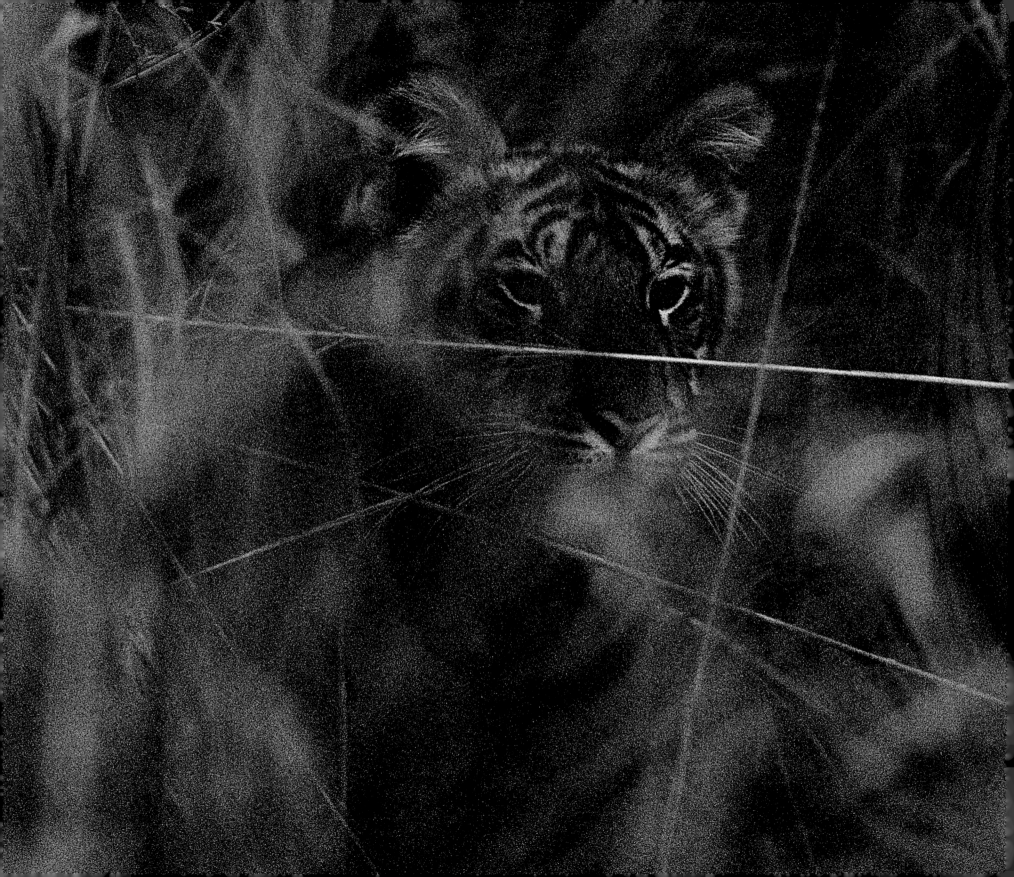

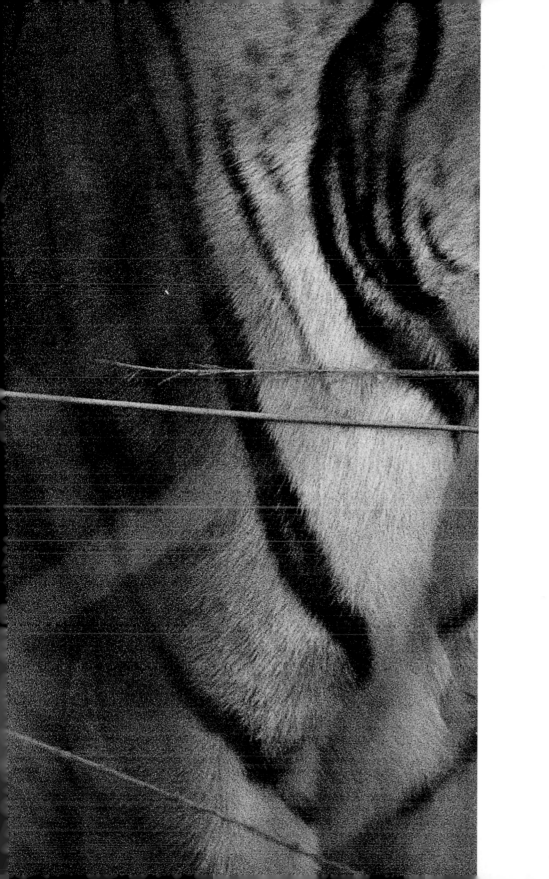

THE TIGER IS A LARGE-HEARTED

GENTLEMAN WITH BOUNDLESS

COURAGE, AND...WHEN HE IS

EXTERMINATED—AS EXTERMINATED

HE WILL BE UNLESS PUBLIC OPINION

RALLIES TO HIS SUPPORT—INDIA WILL

BE THE POORER BY HAVING LOST

THE FINEST OF ITS FAUNA.

Jim Corbett, 1944

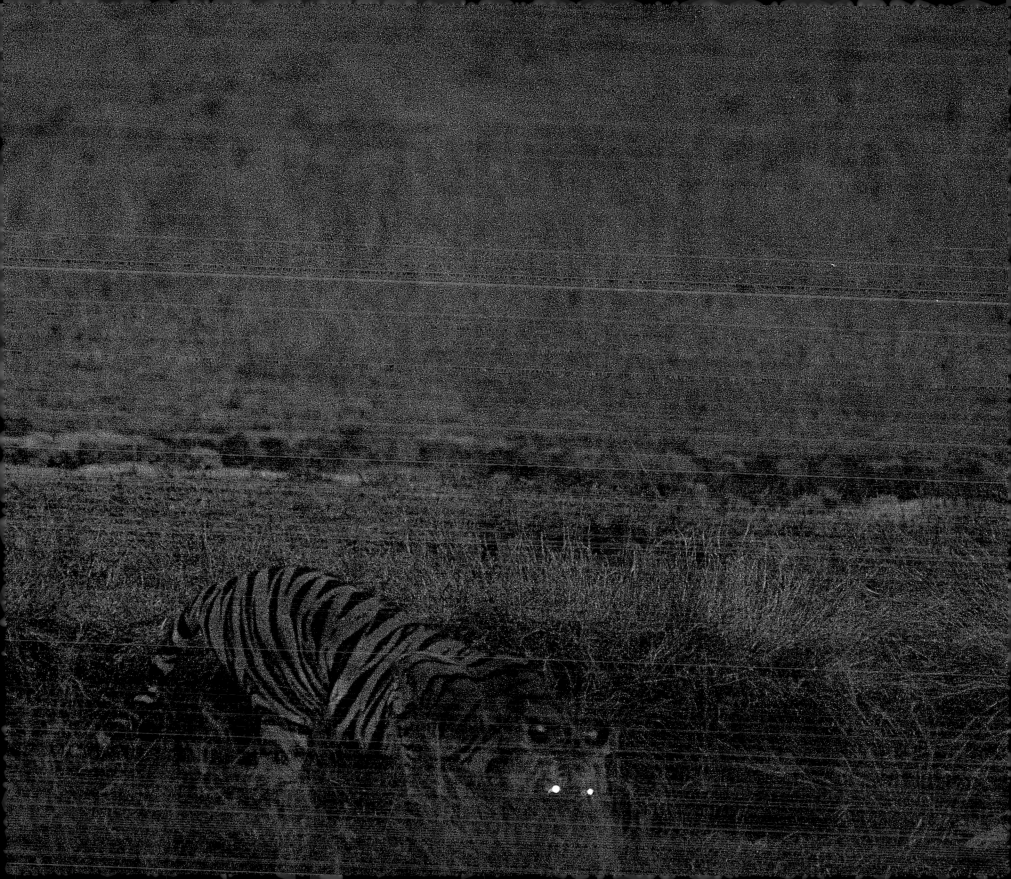

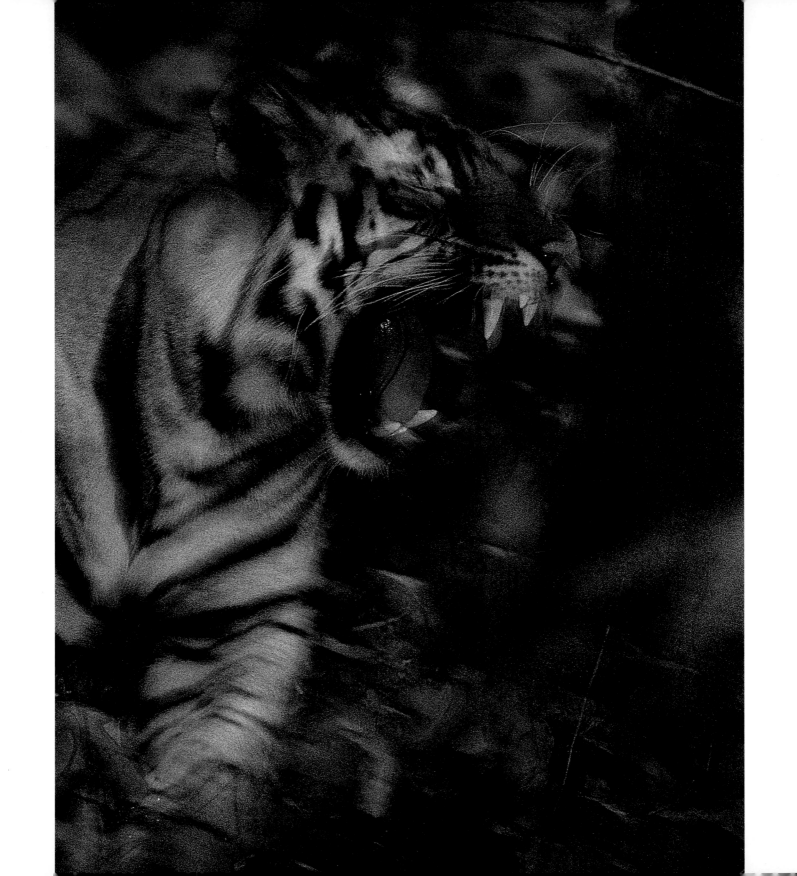

THE YEAR OF THE
TIGER

MICHAEL NICHOLS

GEOFFREY C. WARD

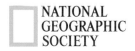

NATIONAL
GEOGRAPHIC
SOCIETY

WASHINGTON, D.C.

I first saw the tigress

called Sita

in January 1987 in Bandhavgarh National Park in the central Indian state of Madhya Pradesh. She lay asleep on a hillside when the elephant I was sharing with the Indian naturalist Hashim Tyabji found her, full-bellied after eating from the spotted deer that lay next to her and exhausted by the steady strain of having to feed and care for her first litter of three cubs. I could just make out the cubs' cries from still higher up the slope amid the expectant cawing of the crows that teetered in the branches of the surrounding trees.

We were just 30 feet or so from the tigress, close enough to hear her steady, sonorous breathing. Three more elephants bearing tourists came and went over the next half hour or so. Cameras clicked. One overly eager photographer dropped a canister of film and the mahout loudly ordered his mount to pick it up with its trunk and return it to its owner. The tigress slept on, oblivious. Nothing seemed to faze her—nothing, until a rufous-and-white tree pie, smaller than a North American magpie, fluttered down onto her kill. She was up and fully awake in a millisecond, swatting at the terrified bird with one enormous forepaw and roaring so loudly the sky seemed to split.

It was the first time I'd been so close to so much tiger anger. I was thrilled but frightened, too, and looked to Hashim for an explanation. Why had she become so furious so fast?

He smiled. "Tigers," he said, "do not like to share."

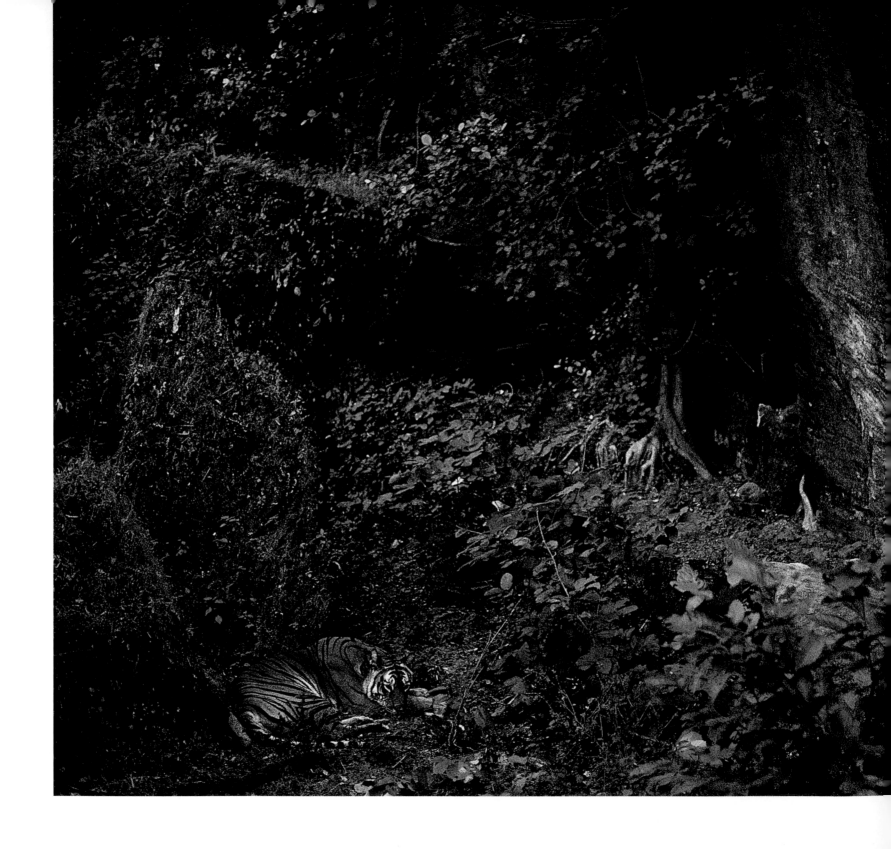

At rest after a night's hunting, the tigress Sita remains ready to fend off any intruder that comes too close to the hidden cliffside cave in which she has placed her small cubs.

In the spring of 1997, I was back at Bandhavgarh starting out again at dawn, riding the same elephant with the same mahout, and looking for the same tigress.

Sita was said to be nearly 15 now, unusually old for a tigress in the wild, and she had given birth to 5 more litters over the 10 intervening years. A total of 18 cubs have been born to her. Just seven made it to adulthood. The rest all died or disappeared: One young male was killed by an adult male seeking to displace its father, another drowned in a monsoon flood; a female cub suffered from physical deformities, mysteriously lost her eyesight, then seemed to waste away. And all three offspring from Sita's fifth litter—born in March 1996—died barely two months later. No one knows for sure what happened to them.

Still, fewer than ten days after the loss of her fifth set of cubs, Sita was seen mating again, with the big, testy resident male. He is nicknamed Charger because of his enthusiasm for doing just that, once clawing his way up the back end of an elephant when it got too close and in the process traumatizing the visitors on board. (In fact, Charger has never actually harmed a human being; he rarely harms an animal for that matter. Rather than exert himself unduly, he prefers that Sita and the other three tigresses within his range do his killing for him, then he moves in for a free meal.)

The forest was still dark as we set out, and our fleet of five elephants moved along in almost total silence. But around us there were already morning sounds: Peacocks called from their nighttime roosts and were answered by the raucous barnyard crowing of jungle fowl, gaudy ancestors of the domestic chicken. Gray langur monkeys gave out the low self-satisfied hooting with which they greet the day and warn one another to be on alert.

Ahead of us we could just make out a broad stretch of swampy grassland, where I hoped to see Sita again and, if I was very lucky, catch a glimpse of the new litter of cubs said to be somewhere in the area, as well.

One evening not long before I left for India,

the former head of one of America's best known zoos appeared on a nationally televised talk show, clad in safari clothes and holding a live cub in his arms. He offered a few details about tiger habits along with a grim prophecy about the future of the species. Tigers kill their prey by breaking the neck, he assured his host, then bury them overnight. Only 2,000 tigers remain in the wild, he continued, and all of them will be gone by the year 2000. The only surviving tigers will be in zoos.

His heart may have been in the right place, but everything he said was suspect. In fact, tigers throttle most of their prey—in the field, the distinctive throat wounds left by their big canines often provide the best evidence that they have been at work. And while they do conceal their kills as best they can in brush or leaves or tall grass, they do not bury them. Nor has anyone any real idea how many tigers survive in the wild—the dearth of reliable numbers is one of the most frustrating aspects of tiger conservation. There is no question that the species is in trouble throughout its remaining range, but however many tigers there are, there is no reason to suppose tigers will all be gone by the turn of the century—or anytime soon after that—provided governments intensify their efforts to protect them, good science is applied to their conservation, and well-meaning alarmists don't convince the public that their rescue is a lost cause.

Tigers are generally believed to have evolved in southern China more than a million years ago, and then to have prowled westward toward the Caspian Sea, north to the snow-filled evergreen and oak forests of Siberia, and south, across Indochina and Indonesia, all the way to the lush tropical forests of Bali. Their modern history is admittedly dispiriting. Into the 1940s, eight supposed subspecies persisted in the wild. Since then, however, the tigers of Bali, the Caspian region, and Java have all vanished, and the South China tiger, hunted as vermin during the regime of Mao Zedong, seems poised to follow them into extinction; fewer than 30 individuals may now survive outside zoos, scattered among four disconnected bits of mountain forest, probably too few and far between ever again to maintain a viable population.

Just four other subspecies remain, and well over half of the tigers surviving in the wild are believed to live in India and neighboring Nepal, Bhutan, and Bangladesh. When I started writing about Indian tigers in the early 1980s, their future, at least, seemed assured. Shooting them had been

banned since 1970 and there were stiff penalties for anyone caught trying. Project Tiger, undertaken at the instigation of Prime Minister Indira Gandhi in 1973, had set aside 9 national parks for special protection (14 more have been added since). The core areas of these tiger reserves, off-limits to humans, were meant to be "breeding nuclei, from which surplus animals would emigrate to adjacent forests." Broad buffer zones, into which human incursions were to be strictly limited, were intended to protect the breeding grounds against disturbance. It was an extraordinary commitment for a relatively new nation beset by other, more pressing challenges; no Western country has ever mounted so serious an effort to save a magnificent but potentially deadly predator in such proximity to its citizens.

The program seemed to be working. In 1984 forestry officials declared that the number of wild tigers in India alone had more than doubled, from 1,827 individuals to better than 4,000. Project Tiger seemed so successful, its reserves were said to be so full of tigers, that some conservationists worried most about what would happen to all the surplus animals.

Then we began to get the bad news. The assassination of Mrs. Gandhi in 1984 swept from the scene Indian wildlife's most powerful defender. Afterward, as effective political power slowly shifted from the central government at New Delhi to local politicians in the individual states, enthusiasm for defending India's jungles slackened under pressure from ever growing numbers of poor voters who saw them primarily as easy sources of fuel, fodder, and forest products. The authenticity of the gains Project Tiger had claimed came into question as well. No one doubts that the number of tigers really had risen. But in reaching their ever more impressive tallies, forest officials had relied on identifying individual pugmarks, or paw prints—a system since shown to be unreliable—and then, concerned for their jobs if the number of animals under their care didn't steadily climb, some had inflated their already shaky findings well beyond the numbers the resident prey base could conceivably have sustained.

Meanwhile, the human population continued to climb. Promised forest corridors between the parks were turned into farmers' fields, inundated by dams, honeycombed with mines. Many of the "adjacent forests" to which the corridors were

meant to lead simply vanished. There were fewer and fewer places to which young tigers could disperse, and more and more conflicts between tigers and human beings.

Then, beginning about 1986, something else began to happen, something mysterious and deadly. Tigers began to disappear. It was eventually discovered that they were being poisoned and shot and snared so that their bones and other body parts could be smuggled out of India to supply the manufacturers of Chinese traditional medicines. Mixtures containing tiger parts have been used for centuries in China and in Chinese communities overseas. Millions of people believe in the efficacy of tiger parts against fever, rheumatism, and a host of other illnesses. After the virtual disappearance of the South Chinese tiger in the late 1980s, stockpiles of tiger bones were depleted, and resupplying them became a big business. No one knows how many tigers in India fell victim to this illicit trade, but the figures compiled by Ashok Kumar and Belinda Wright, whose tiny Wildlife Protection Society of India has spearheaded the fight against poaching on the subcontinent—94 tigers killed in 1994, 116 in 1995—represent only a small part of a very grim picture. Most poaching goes undetected, after all; the real number of butchered Indian tigers must have been much higher.

This deadly trade endangers not one but two embattled species: Tiger bones are smuggled northward across the Himalaya and bartered for wool taken from the carcasses of the increasingly rare *chiru,* or Tibetan antelope. The wool is used to make *shahtoosh* scarves, officially banned in most countries but still widely available and prized both for their warmth and a texture so fine that even a very large one can be pulled effortlessly through a finger ring. "One shahtoosh shawl equals one poached tiger," says P. K. Sen, the head of Project Tiger. "The murder of both these animals must be stopped."

Ranthambhore National Park in eastern

Rajasthan—with its blue lakes, sprawling hilltop fortress, and ancient ruins scattered throughout the forest—was the pride of Project Tiger when I first visited it, famous both for the

With infinite tenderness,
Sita carries one of her cubs
to a new hiding place.

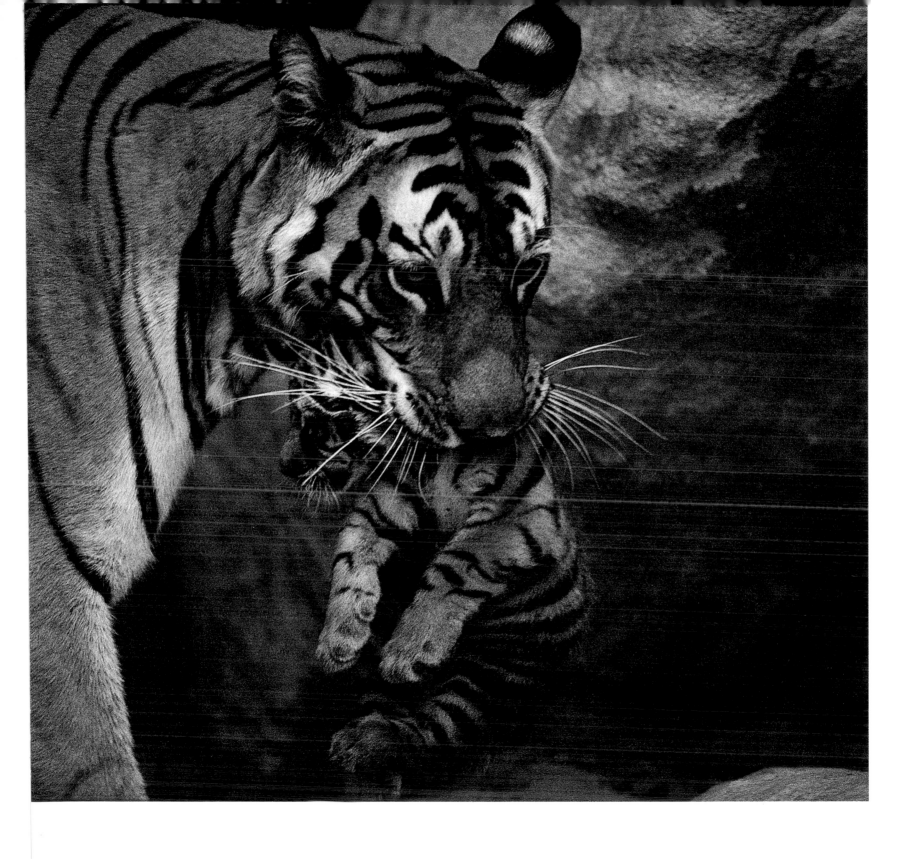

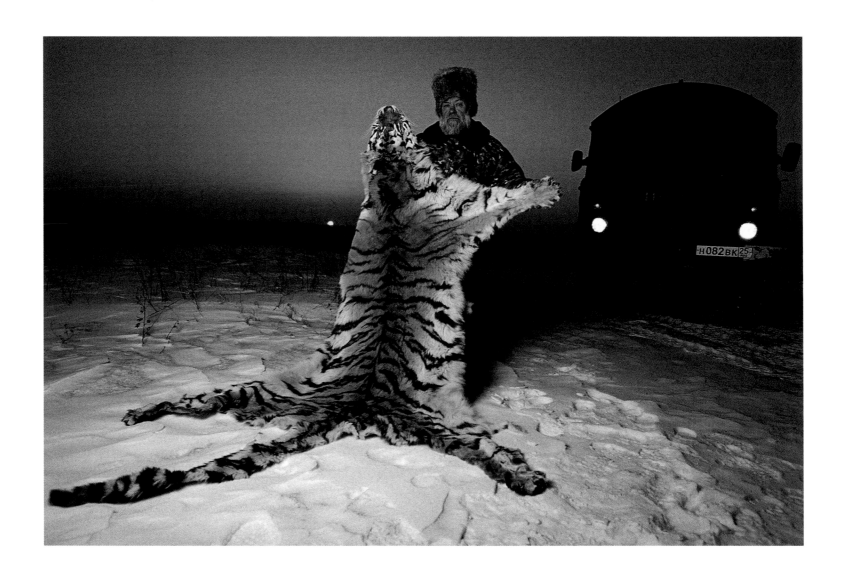

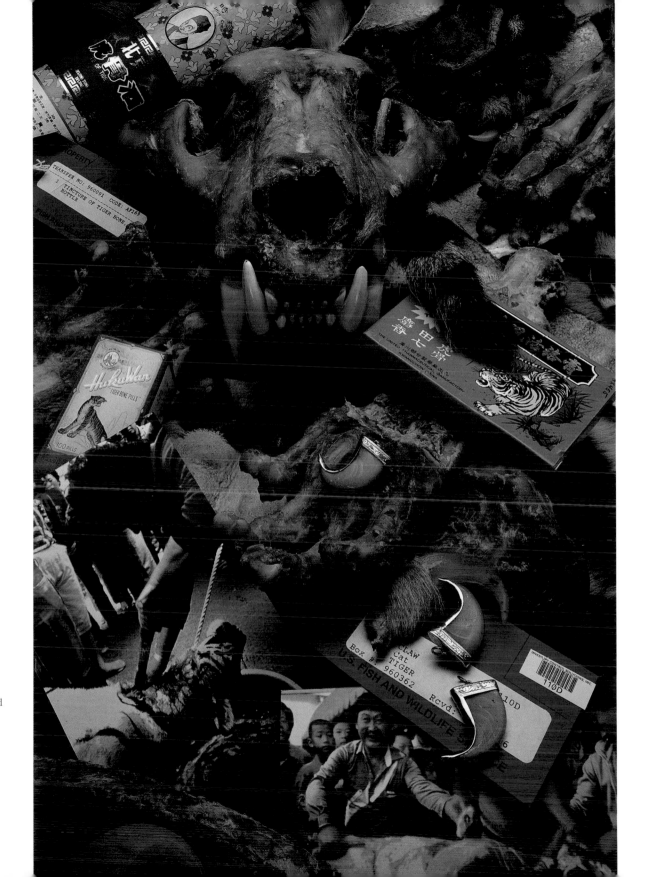

Spoils of a conservation war: Vladimir Shetinin (opposite), leader of a Russian anti-poaching squad, displays an impounded pelt in Siberia. This ghoulish sampling of illegal tiger products (right) was rounded up in the United States by the U.S. Fish and Wildlife Service.

deep inside the jungle. In an instant the bulls forgot their rivalry and vanished into the undergrowth; each of them represented a 2,000-pound breakfast to a tiger.

Tigers are so beautiful, so powerful, so secretive, so shrouded in myth that the daily reality of their lives can seem prosaic. Tigers do not "roam" the forest as romantic writers like to have them do; instead they doggedly work carefully delineated territories, on the lookout for their next meal—and on the alert for any other predator that threatens access to it. They need meat, massive amounts of it, just to stay alive. An adult Bengal tigress on her own eats an average of 13 pounds every day, 4,700 pounds every year; a tigress with two cubs can demand more than 6,800. That's somewhere between 40 and 70 kills annually. It takes enormous energy to do all that killing—observers at Ranthambhore estimated that the average tiger made 10 attempts before it managed to pull anything down; tigers in the more densely forested Kanha National Park took close to 20 tries—and it is therefore far more efficient for tigers to hunt big animals than small ones. The tigers of Nagarahole routinely feast on massive gaur, favoring them over the much smaller spotted deer that are the staples of tigers' diet in other forests.

Karanth and his colleague Mel Sunquist of the University of Florida have shown that the Nagarahole forests provide 32,385 pounds of meat for every square mile, such a staggering amount of prey in so many different sizes that all three of India's large carnivores—tiger, leopard, and wild dog—are able to flourish here side by side. But in parts of Thailand, for example, where large ungulates have been hunted almost to extinction, tigers now struggle to survive on porcupines, monkeys, and 40-pound muntjacs. "Indochina, with its huge forests, ought to provide the greatest potential for tiger preservation," Karanth says. "But the prey is all buggered-up."

Studies by Karanth, Sunquist, Seidensticker, and others suggest that density of suitable prey is the most reliable indicator of how a tiger population is likely to fare. And history bears them out. Tiger hunting and loss of habitat were once blamed for the loss of the Bali, Caspian, and Javan tigers—and both surely played a part in their decline. But the latest research suggests that it was the loss of their prey that finally made their lives literally insupportable.

Karanth doesn't minimize the seriousness of poaching.

"If it continued at the levels it reached in the early nineties, it could provide the coup de grâce for the species in India," he says, "and we should be ruthless in dealing with anyone involved in it." But there will probably always be some poaching, he continues, and a healthy tiger population can tolerate a reasonable amount of it: "Suppose a forest holds 24 breeding females and each year 8 of them give birth to a litter of 3 cubs. That's 24 cubs. In the natural course of things, half the cubs will die before their first birthday. If properly protected and fed, the surviving 12 will either disperse or kill and replace an already existing tiger. So in a healthy community there's always a doomed surplus."

As long as poachers don't remove more than that number, Karanth argues, the population should remain more or less stable. (If poachers do exceed that number—as they came close to doing at Ranthambhore—all bets are off.) But if the prey base collapses, if tigresses begin to have trouble feeding themselves let alone their cubs, populations plummet.

"That sort of basic knowledge is essential if tigers are to be managed properly," Karanth says. "The role of good science is to set the standard for what potentially can happen in a park and then offer ways by which managers can accurately assess their own work. Instead of indulging in this crazy numbers game of trying to count every single tiger, we are trying to introduce basic sampling techniques to monitor success or failure. Studying prey—counting deer pellets and picking apart tiger scat to see what they've been eating—is unglamorous," he admits. "But after providing protection, management's most important role should be to build up the prey base. With enough to eat, enough space, and enough protection, tigers will take care of themselves."

The three subspecies that survive elsewhere

in Asia—the Indochinese, Sumatran, and Siberian (or Amur) tigers—face all manner of threats. But the most serious in every case is the potential loss of prey.

Tigers remain in six Indochinese countries—Cambodia, Laos, Malaysia, Myanmar (Burma), Vietnam, and Thailand. But all have suffered war or civil unrest in the past half century,

and their interiors have largely been off-limits to scientists. While forest still covers much of the region, no one knows how much wildlife survives beneath its canopy.

George Schaller, the peripatetic director for science at the Wildlife Conservation Society, whose pioneering 1967 study, *The Deer and the Tiger,* set the standard for scientific research on the animal, is not optimistic. "I'm afraid there are very few tigers left in Indochina," he says, "and there are very few trained researchers to study them. Forests look intact from the air, but many are alarmingly empty on the ground. In Laos you can walk for weeks in the rain forest and never see a pugmark—less because of tiger poaching than because local people have snared and eaten all but a few barking deer. The remaining tigers are forced to wander for miles in search of their next meal. When you ask villagers if there are tigers nearby, they answer, 'Yes, one came by here a year ago.' Most populations are too small and scattered to survive much longer."

Schaller's colleague Alan Rabinowitz, one of the few scientists to have worked extensively in the region, agrees. "Deer are disappearing everywhere," he says. Four of the six species that were mainstays of the tigers' diet in Thailand have been virtually annihilated. Commerce in wild animal parts continues to flourish. All of the six range countries except Laos have signed the Convention on International Trade in Endangered Species (CITES) agreement. But tiger parts are still sold openly in the marketplace alongside bits and pieces of the animals they once fed upon; in one Myanmar bazaar, tiger skin was being sold for $5 per square inch; an inch of rib cost $4.50.

"If the tiger is to survive in Indochina, governments will have to act fast," Rabinowitz says. "Local people will not save tigers on their own. Why should they? There's nothing wrong with long-term schemes aimed at involving local communities in conservation. But we haven't time to wait for them to work. We need first to find out where the remaining tigers are. Then we need a triage system like the one used in battlefield hospitals, to separate those populations large and strong enough to have some hope of survival from those probably too weak to make it. Finally, governments will have to designate protected areas for tigers, then commit the resources necessary to guard and manage them without compromise. Otherwise, we'll lose the Indochinese tiger."

The news from Indonesia is more encouraging. It was once home to the Balinese, Javanese, and Sumatran subspecies. Now only the tigers of Sumatra remain and until recently many authorities believed they were about to disappear as well. But findings by a mostly Indonesian team, headed by Ron Tilson, director of conservation at the Minnesota Zoo, suggest that reports of the Sumatran tiger's imminent demise may have been premature. The study area, Way Kambas National Park near the island's southern end, seems an unlikely source of hope. More than half a million people live along its border, and much of the forest has been logged in recent times, some parts more than once. It was thought until 1995 that no more than 24 tigers survived within the whole park. During the Tilson team's initial 15 months of studying one 62-square-mile section of it, its members glimpsed tigers just twice.

But when they used modern sampling methods, including camera traps tripped by passing animals, they discovered that their study area alone—just over one-eighth of the park—was home to 6 tigers and regularly visited by 12 more. They now believe Way Kambas may contain as many as 36 tigers and are training "rapid assessment teams" to survey Sumatra's other parks and unprotected forests to see if tigers are underreported there as well. Indonesian authorities estimate there could be as many as 500 tigers scattered in reserves all across the island plus another 100 in unprotected areas, and Tilson and his researchers have helped the government draw up a comprehensive management plan to save as many of them as possible. "There's an old Malay saying that attests to the persistence of the tiger's spirit," Ron Tilson says. " 'The tiger dies, but his stripes remain.' In Sumatra our job is to provide the information and the means to help the people of Indonesia ensure that both the stripes and the tiger survive."

The Siberian tiger once occupied Chinese Manchuria and Korea as well as the Russian Far East. Except for perhaps 20 scattered individuals thought to survive in northeastern China and North Korea, it is now confined to a single 625-mile-long strip of mountainous terrain along Russia's easternmost fringe. When the Hornocker Wildlife Institute launched its Siberian Tiger Project in and around the Sikhote-Alin Biosphere Reserve in 1992, *(continued on page 38)*

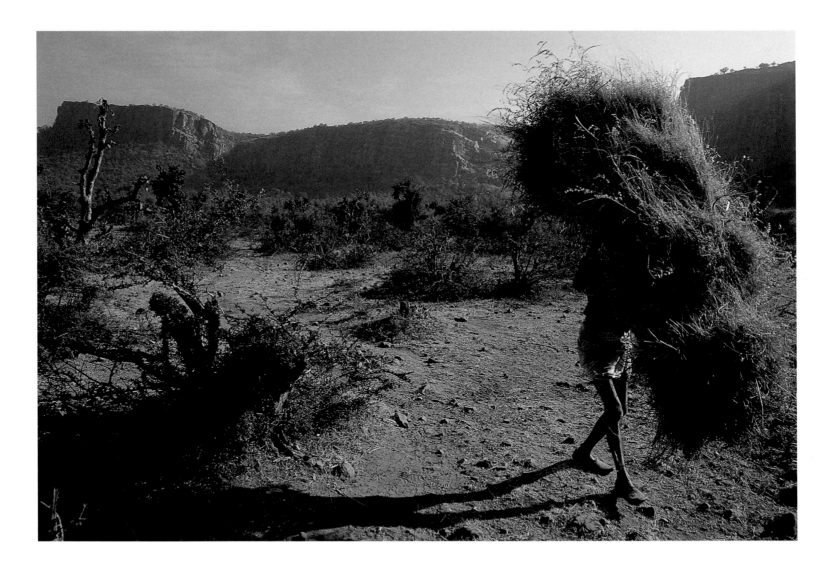

On the fringe of Ranthambhore National Park in Rajasthan, villagers seeking fuel and fodder
and voracious herds of domestic cattle have combined to turn prime tiger habitat into a desert.

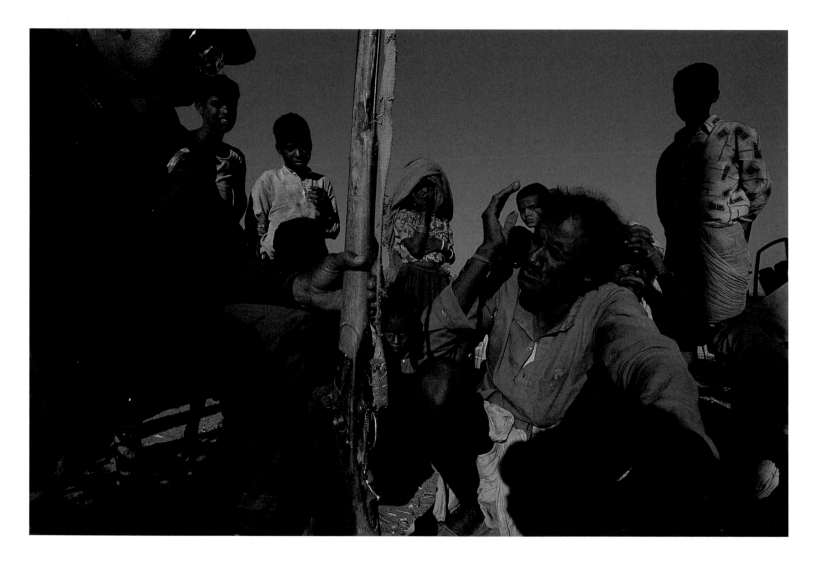

Fateh Singh Rathore, Ranthambhore's former field director (above), confronts a crudely armed tiger poacher, while his son, Dr. Goverdhan Singh Rathore (opposite), works to persuade local people to plant their own trees rather than rely on the forest for shade and fuel.

the tigers' prospects looked very nearly hopeless. A series of hard winters in the mid-1980s, followed by still harder economic times that accompanied the collapse of the Soviet Union, drove local people to hunt for food, taking an ominous toll of the elk and deer and wild boar upon which the remaining tigers depended. Unregulated logging and mining threatened to shrink the tigers' home. Tiger poaching was rampant. Between 1992 and 1994, 40 to 60 tigers were trapped or shot each year and their bones and skins sold in China.

But in the past four years the situation seems to have improved dramatically. In 1995 Russian Prime Minister Viktor Chernomyrdin called for a national conservation strategy. Patrolling was intensified, the Chinese border was better regulated, and poaching was reduced.

During the winter of 1995–96, some 650 men, led by Evgeny Matyushkin of Moscow University, coordinated by American researcher Dale Miquelle, and funded largely by the United States Agency for International Development, undertook a systematic census of the entire region. Nothing so comprehensive had ever been attempted. Tiger tracks were followed, measured, and cataloged over 58,000 square miles of snow-filled mountain forest. The results surprised nearly everyone—there were signs of somewhere between 430 and 470 adult tigers and cubs, nearly twice as many animals as some had estimated just a few years earlier.

The Siberian tiger seems to be slowly edging its way back from oblivion. To continue this hopeful trend, the Hornocker Institute, working closely with Russian scientists, has drawn up a master habitat protection plan aimed at ensuring that the Siberian tigers' home shrinks no further. It calls for an inviolate core area, a network of protected areas linked by corridors to allow safe dispersal of young males, along with careful management of the surrounding unprotected forest to ensure that logging and mining and road-building do the least possible damage to tigers and their all-important prey.

"In the Russian Far East we remain optimistic," says Dale Miquelle. "Yes, there's still poaching. Yes, there's a lot of logging. Yes, there's too much hunting of ungulates. But there's also still a big stretch of more or less intact forest. Human pressure is low—and not likely to rise. If the Russians extract timber at a sustainable rate, if hunters can be persuaded to remove prey at a rate that allows tigers as well as themselves to eat, if the need or desire to poach tigers can be eliminated, tigers will survive in Russia for the foreseeable future."

The Russian Habitat Protection Plan

is meant to save the tigers of one country. An international consortium of experts has also drawn up a loose framework for saving tigers all across Asia. The Wildlife Conservation Society and the World Wildlife Fund, U.S.A., have combined satellite imagery with preliminary field assessments to produce a map of tropical Asia that identifies 159 "Tiger Conservation Units," or TCUs—bits of forest in which tigers are still thought to have a fighting chance.

"It's just a start," says John Seidensticker, who also heads the council of advisors of the Save the Tiger Fund, which helped pay for the survey. "We can't possibly save all the TCUs. Some of the most marginal populations will blink out in the next few years. Some may already have blinked out since the map was made. And areas that look thickly forested from space may actually be empty of animals; we don't know yet. Now we need to assess these areas on the ground as fast and accurately as we can, settle on, say, 25 areas with the most potential for long-term survival, and then lobby governments and funding organizations to concentrate on saving those whatever else they choose to do."

A first look at the map is discouraging—the areas of potentially viable cover seem thin and alarmingly scattered—and closer examination only adds to one's unease.

Nagarahole National Park, for example, forms part of a Tiger Conservation Unit that runs for almost 400 miles and touches upon three states—Karnataka, Kerala, and Tamil Nadu. It is one of 25 areas designated as level-one TCUs, those "offering the highest probability of persistence of tiger populations over the long term," and four of the best-known forests in south India are included in it—Bandipur, Wynad and Mudumalai, as well as Nagarahole. But there are also human settlements within its borders, lengthy stretches of hillside on which coffee plantations have long since displaced tiger jungles, and ragged parcels of threadbare forest that will require serious attention before they can do much for the persistence of tiger populations.

Ullas Karanth took me to see one of these last, a largely neglected wildlife sanctuary in Karnataka called Bhadra. With us were two friends, Peter Lawton, a ginger-bearded Briton then representing the London-based Global Tiger Patrol, and Valmik Thapar, the New Delhi author and tiger-watcher who has in recent years become the Indian predator's most vocal spokesman in and out of the corridors of power.

Bhadra is a 191-square-mile forest ringed by mountains. Its floor is blanketed with yellow leaves from the three kinds of bamboo that grow there. The largest variety produces dense whorls 40 feet tall whose creaks and groans provide an eerie background chorus whenever there is the faintest breeze. Strangler figs festoon even the biggest trees. We saw elephants and wild dogs, noted signs of gaur and spotted deer, watched jewel-like birds—scarlet minivets, golden-backed woodpeckers, the blue-green Indian pitta—and were fooled at first by the call of the Malabar whistling thrush, which sounds uncannily like a cheerful schoolboy unable to decide which tune to try.

We stayed the night in a rest house more than halfway up a mountainside. As we dined on the terrace, a full moon floodlit long, shredded wisps of fog that hung above the dark forest far below.

Karanth is normally a careful, measured man, but Bhadra clearly excited him. "This place has everything," he said. "With all that bamboo, it could support a really big population of gaur and other herbivores. I think it might eventually produce a biomass even bigger than Nagarahole's. All it needs is protection."

But Bhadra has enemies both without and within. Commercial bamboo cutters have won permission to work within the forest. There are five small villages inside the sanctuary whose residents eke out a precarious living growing rice in low-lying swamps. They dream of tarmac roads, electricity, running water, and all the other improvements that people living outside the forest take for granted. Their desire to better their conditions is entirely understandable, but the forest department has successfully blocked all such plans; "improvements" like these within this fragile forest would eventually destroy it.

Karanth believes that in the end, breeding tiger populations and human beings simply can't occupy the same spaces, that projects meant to benefit human beings must be limited to areas outside tiger parks and sanctuaries. "Tigers occupy less than two percent of the Indian land mass," he continued. "People have all the rest, and sacrificing these last few precious places won't solve any of their problems. We can protect them if we have the will."

The sawing of a leopard began from somewhere farther up the slope. Thapar agrees that protection should be the first priority—"but not just against poachers or poor villagers, also against mining interests and logging companies and all the rest of the interests that would destroy what remains of our forests if given half a chance."

"But how can anyone expect the state forest departments to fight all those forces?" I asked. Everywhere I went its officials seemed understandably demoralized, underpaid, and hesitant.

Thapar nodded: "Government alone can't do it anymore. That's why we're trying to build up a parallel citizens movement made up of interested local people willing to support officers when they do their duty and to criticize them when they slack off—a sort of 'sweet and slap' system."

When I first began visiting Indian forests, tiger enthusiasts were as determinedly territorial as the animals they loved, dedicated only to saving the forests they knew best and sometimes actually unaware of one another's existence. Thapar's Tiger Link, an all-India network of concerned individuals and organizations, was created several years ago to help change all that. The densely packed pages of its newsletter are filled with bulletins from all over the subcontinent and provide a lively, if sometimes dispiriting, overview of how the species is faring. In the summer of 1997, members of Tiger Link and their political allies persuaded 320 members of parliament representing more than 250 million people to sign an appeal to the prime minister demanding that the central government reorganize and strengthen tiger protection.

Meanwhile, Ullas Karanth serves as scientific advisor for Wildlife First, a local Karnataka organization headed by K. M. Chinnappa, the legendary ex-forest officer who made Nagarahole one of Asia's finest parks. It is made up of dedicated volunteers willing to put in time working with officials in forests of which they are especially fond. Developments at Bhadra are under the watchful *(continued on page 44)*

Mammoth gaur make up a sizable part of the diet of the tigers of Nagarahole National Park,
which Ullas Karanth (opposite, seeking signals from a radio-collared tigress) has been studying
intensively for 12 years.

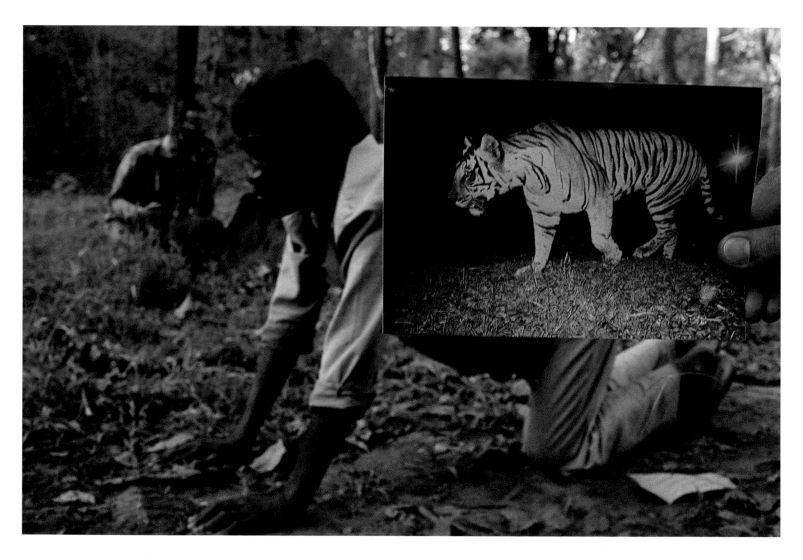

A member of a local tribe helps Ullas Karanth focus his remote trailside camera, one of many that have yielded an irreplaceable nighttime record of Nagarahole's tigers (opposite), each identifiable by its singular pattern of stripes.

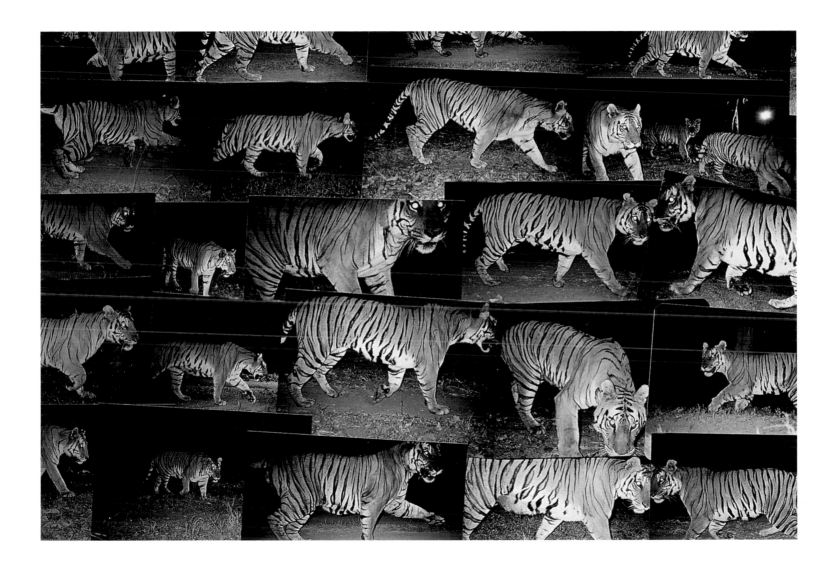

eye of an eager young coffee planter named D. V. Girish, who had accompanied us as we drove through the sanctuary.

Here and there below us in the darkness were bright eruptions of orange flame.

"Forest fires," Girish explained. "Villagers set them just to get back at the forest department."

The department was largely powerless to put them out; it had no vehicles.

Clearly action was needed if Bhadra were ever to fulfill its potential as a home for tigers. Peter Lawton agreed to see what he could do about providing jeeps. Thapar and Karanth planned to try to have the sanctuary placed under the protection of Project Tiger.

As we said good night, the leopard continued to call among the moonlit trees.

We have only a vague notion of how many

tigers survive in India's protected areas. No one has a clue how many cling to life outside them. Estimates vary wildly from more than half of India's tigers to less than 20 percent. But I know for a fact that they exist.

One morning a year or so ago, I pulled off a forest road in Uttar Pradesh to stretch my legs. The nearest national park was miles away. The trees on either side of the road were the property of the forest department, but managed for timber, not wildlife, and most of the undergrowth had long-since been devoured by the dusty buffalo seen here and there, nosing after what little foliage was left. Four men on bicycles clattered past, returning from the nearest bazaar with empty milk cans tied behind their seats. A tractor chugged loudly along behind them, driven by an old bearded Sikh, its trailer packed with cheerful, shouting children. A spavined, gaily painted truck overloaded with sugarcane roared past in the opposite direction, horn blaring, black smoke spewing from its exhaust pipe. The lowest leaves of the trees on both sides of the highway were coated black with grime left by the steady stream of trucks that passed beneath them every day.

But as I stepped out into the roadside dust, in the midst of all this clamorous human activity, I looked down and saw the saucer-size pugmarks of a big male tiger, so sharply

defined, so obviously fresh, that I spun around to see where it had gone. As I did so, a langur coughed angrily from the topmost branches of a tall tree to my left. A moment later, the tiger stepped out from behind another tree, perhaps 50 yards down the road. It gazed back at me, turned to watch the four unwitting cyclists who had just peddled past him, then darted across the road and vanished into the wrecked forest on the other side. The langur and I alone had seen him—he had been in the open only for a second or two, but he was there.

How long can tigers survive in such unlikely places? A researcher named Raghu Chundawat, a member of the faculty of the Wildlife Institute of India, is trying to find out in and around Panna National Park, a day's drive north of Bandhavgarh in Madhya Pradesh. Panna is a comparatively new park. Created in 1982 from the former hunting reserve of local nobility, it has been under the Project Tiger umbrella only since 1995. And 15 crowded villages still remain within its boundaries, their livestock competing with wild ungulates for the coarse grasses that now cover the fields where wheat and mustard once grew.

The Ken River twists through Panna's heart. While Chundawat and I sat on big water-worn rocks and talked on one bank of the river, three crocodiles lay motionless in the sun on the other. A huge Arjun tree stood nearby, its thick silver-gray trunk tiger-striped by the claws of generations of hungry sloth bears clambering after honey.

Chundawat chose Panna for his study, he explained, because the large amount of human disturbance and low density of wild prey that occur here are characteristic of the dry tropical forests in which most of the subcontinent's so-called "forgotten tigers" struggle to survive. His preliminary data offer vivid proof of how hard that struggle is.

After intensive monitoring based on radio-collaring and long hours of close observation, Chundawat estimates that Panna is home to some 20 tigers (all but 5 of them cubs). On paper the park, at 209 square miles, seems big enough to support a far larger population; Ranthambhore, for example, roughly three-quarters Panna's size, may have once held more than 40 tigers. "But tigers don't live on paper," Chundawat explains. The resident male regularly has to travel outside the park in search of food, usually taking village

cattle from which he dines just once, never returning to his kills for fear angry herdsmen will be waiting for him. Only one of the three tigresses raising his cubs can feed herself exclusively in the relative safety of the park itself. The rest are all forced regularly to emerge from it to hunt, running an ever greater risk of being poached or poisoned or hit by one of the trucks that hurtle past the park at all hours of the day and night.

Chundawat is not encouraged about the Panna tigers' prospects: If India can't enlarge these places and provide them with effective protection, and if prey species can't be encouraged to proliferate, he says, "I'm afraid these tigers are doomed. They are amazingly resourceful and it may take some time, but eventually they will disappear."

Setting forests aside for tigers is one thing,

ensuring that they remain protected is something else again. No one disagrees with John Seidensticker's view: "Tigers won't ultimately be safe until they're worth more alive than dead." But that is a tall order in countries where space is at a premium, and millions are still in need of the food, fuel, and other products that forests have always provided. To meet that challenge in India, the Global Environment Facility and the World Bank are supporting an ambitious 67-million-dollar ecodevelopment scheme aimed at relieving the human pressure on five tiger reserves. If it proves effective, its authors hope to expand it to cover more than a hundred additional protected areas. Critics worry that such vast sums spent so rapidly in so few areas may inadvertently damage already fragile regions with new roads and other material benefits that may please people but only further threaten wildlife.

More modest projects with great potential are also under way. Villagers were encouraged to reclaim and replant more than six square miles of degraded forest on the edge of Royal Chitwan National Park in Nepal and then allowed to keep half the proceeds from tourists eager to view wildlife. In the first year alone, the villagers earned $308,000 from entrance fees. Best of all from the wildlife point of view, one resident male tiger, a female tiger with two cubs, and transient males now use the area, and at least 12 rhinos have given birth within its precincts. An adjoining 17-square-kilometer patch

has recently been added, and other villages around the park have expressed interest in developing their own profit-producing forests. Eric Dinerstein of the World Wildlife Fund, who helped guide the project, is delighted. "It helps ensure the survival of the park," he says, "plus it adds to the area under protection. If we don't add more forest whenever we can, we'll end up like curators in a small museum, endlessly cataloging our old collections rather than building new ones." Benefits like these, derived directly from wildlife, seem to offer real hope for the future, though each park and each range country will require its own distinctive solutions.

Meanwhile, at Chitwan and everywhere else where tigers survive, protection still requires strict policing. "It always will," says Dr. Karanth. "There is a criminal element even in the most sophisticated cities. We must deal with it in just the same way. We can protect our forests if we have the will. You should really see Kaziranga in Assam. It's the best defended park in Asia."

Karanth was right. "Only God can keep people from killing tigers in other parks," said Bhupen Talukdar, one of three range officers in charge of anti-poaching activity at Kaziranga. He is a fierce, bearded man with bright silver rings on all his fingers. "Here we do it."

They do, indeed, though tigers are only the unwitting beneficiaries of the officers' primary concern: protecting the one-horned rhinoceros. A long, spongy floodplain of the Brahmaputra River, Kaziranga is one of the last strongholds of these massive, myopic beasts. There were just a few individual animals when its swamps and grasslands and patches of semi-evergreen forest were declared a national park in 1903; there are now more than 1,200—more than half of all the wild Indian rhinos left on earth. Like tiger bone, rhino horn is hugely profitable—it, too, is used in traditional Chinese medicine, and a single horn can bring more than $8,000 on the black market—many times the average annual income of the people who live around the park. Between 1989 and 1993, 266 rhinos were butchered in India for their horns. Kaziranga lost 49 animals in 1992 alone.

But, Talukdar explained, "The rhino is in the Assamese psyche. Lord Krishna is supposed to have brought it to Assam to fight an evil king, using it just like a tank. We are determined to protect it." In 1994, he and *(continued on page 50)*

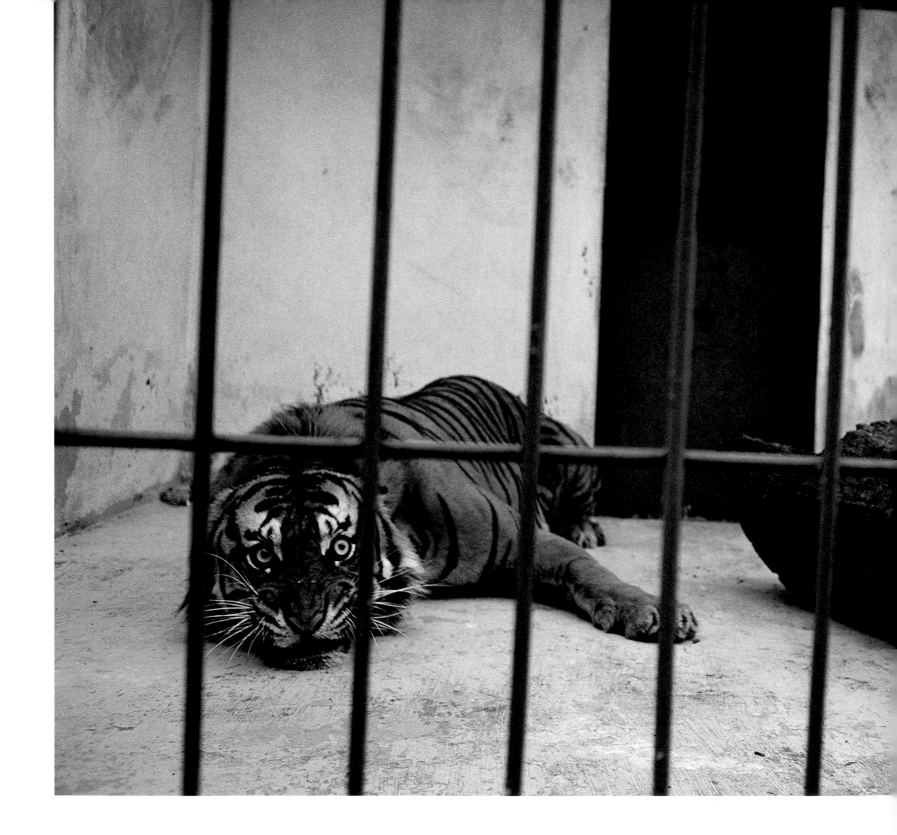

Nine years after its incarceration,
a once-wild Sumatran tiger remains
anxious, part of a captive-breeding
program at Taman Safari Indonesia
near Jakarta.

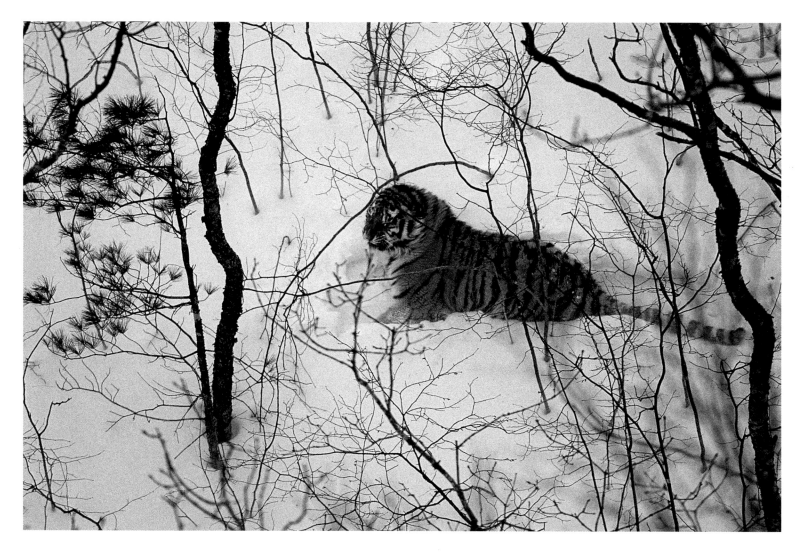

The Russian tiger's range (opposite) is so vast that helicopters are used to track animals such as this male (above), the son of a radio-collared tigress named Olga, who routinely prowls 255 square miles in search of food.

his two equally tough-minded colleagues—Pankaj Sharma and Dharanidhar Boro—were given the job of waging the day-to-day struggle required if India is to save the species and the extraordinary ecosystem over which it reigns.

Kaziranga has many of the same problems that beset other sanctuaries all over Asia, plus a few distinctly its own. Like Ranthambhore, it is dangerously small—just 166 square miles—and long-standing plans to expand it have stalled. There is no buffer zone: Villages and paddy fields march right up to the park boundaries. Just across the Brahmaputra are crowded camps of poor Bangladeshi refugees, some willing for a fee to ferry poachers to and from the park at night. The state's finances are often in arrears; when I visited the park, neither the rangers nor the army of some 400 guards who work for them had been paid for weeks. The battered rifles the guards carry are no match for the automatic weapons wielded by intruders. Ammunition is often scarce. Overseas agencies have tried to help by providing a motor boat for patrolling the park's waterways and three jeeps to cover its roads.

There are natural threats to the guards as well: The men must keep on constant alert against charging rhinos, and I was shown the spot where one night a tiger seized a sleeping laborer by the head and managed to carry him away despite the frantic efforts of the man's comrades to drive it off while holding onto his legs. Finally, the great river overflows its banks every monsoon, drowning hundreds of animals and driving hundreds more—tigers and rhinos and elephants, included—up onto the elevated highway that runs along one side of the park and into the nearby hills, where they are easy prey for anyone with a gun.

Yet, against all these odds and more, Kaziranga officials continue to hold the line: Poaching within the park has been sharply reduced from what it was just a few years ago. "We are on a war footing," says Dharanidhar Boro, "and we are fighting wholeheartedly." He does not exaggerate: Guards as well as poachers have been killed in the struggle to save this extraordinary place. There are some 120 permanent outposts within its borders. Within ten minutes of the sound of a shot, armed units can be on the scene. An expert rhino poacher might be able to saw off the precious horn and race out of the park again in that amount of time—though

at least 20 intruders have lost their lives trying to do just that in the last four years. But tiger poaching in Kaziranga is virtually impossible. "No one can skin a tiger in so short a time," Talukdar explains. "And they can't bury it either. The smell lasts for a month. It can't be hidden."

The result is that Kaziranga, largely off-limits to poachers and filled with all manner of prey, remains something like a paradise for tigers and the animals they hunt. Under Ullas Karanth's direction, a team of young researchers working with camera traps in one small section of the park has recently captured enough individual animals on film for Karanth to guess that Kaziranga may be home to more than 85 tigers, including cubs. Each one's stripes are distinctive, explains Karanth, "a sort of bar code by which tigers can be identified." Prey and tiger density here may be even greater than at Nagarahole.

But a day or two spent driving through Kaziranga also offers the most vivid possible reminder that the tiger is only the most charismatic actor on a crowded stage. Above the yellow ten-foot-tall grass, against the Kodachrome-blue sky, shrieking flocks of green parakeets fluttered in and out of silk-cotton trees covered with crimson flowers; the fleshy fallen blossoms, the size and shape of six-fingered gloves, patterned the path ahead of us, forming a red carpet as we rolled forward in our jeep. Farther along, a crested serpent-eagle struggled to get off the ground, a big crow-pheasant pinioned in its talons.

Wherever the dense walls of grass part to reveal a clearing, there were animals in overwhelming profusion—hundreds of wild boar and hog deer and swamp deer, scores of sleek black buffalo with horns like scimitars, rhinos that look as large as fire trucks. On the edge of a shallow lake late one afternoon, two groups of elephants filed gravely past one another without a sideways glance; I counted 58 cows and calves and one magnificent lone tusker before they all glided into the grass again and disappeared.

The next evening a cow rhino, concerned for her calf and agitated by the sound of the jeep in which Pankaj Sharma and I were riding, suddenly whirled, kicking up dust, and charged straight for us. Sharma is a big man with a big voice, but when he clapped his hands and shouted to warn her off she kept coming, amazingly fast, her broad body seeming to

float above the ground, head high, ears straining to make out the source of the annoying sound—Mrs. McGoo at full tilt.

We pulled away. She lost track of us, slowed, sniffed the air, and went back to grazing.

As we headed back to headquarters at dusk each evening, we passed anti-poaching squads on the move along the winding forest tracks. These are the authentic heroes of Indian conservation, little bands of two and three men wearing tattered overcoats and armed with rifles, moving through the mist. Without them this magical world would long ago have vanished. That it has not already done so despite the odds is dramatic proof that with help from scientists and support and understanding from the rest of the world, Asians can save their own forests; the tiger and its world still have a future.

Back on the track of Sita at Bandhavgarh,

the sun was up and somewhere high above our heads a hive of bees, awakened by its warming rays, began to hum. The elephant continued to squelch his massive way through the swamp, leaving behind footprints as big around as wastebaskets.

There were signs of tigers everywhere. Pugmarks crisscrossed the inky mud. Deep within the tall grass lay a clutch of whitened bones, all that remained of a chital kill.

A sleek gray-brown jungle cat, the size of one of its domestic cousins, leaped soundlessly onto a fallen tree, the better to see down into the grass. Something small was moving there. The cat arced high into the air to maximize its pounce, disappeared for a moment, then returned to the log, a mouse wriggling in its mouth, and watched us pass before settling down to eat.

The mahout nudged his elephant to the left, toward a little stream that twists along the base of the hills.

The elephant began to rumble almost imperceptibly.

A tiger was nearby.

The mahout leaned forward, peering through the undergrowth.

Then, there was Sita, sprawled out in a clump of grass overlooking the stream. The crimson rib cage of a half-eaten

chital rested just a few feet away. She gazed placidly at me, just as she had 11 years before. The noisy, odd-looking burdens on the backs of elephants don't seem to register with tigers as human beings—though the sight of a man or woman walking in the forest 200 yards away would have sent her rushing off into the forest. She rolled over and was soon fast asleep again, all four paws in the air, full white belly exposed to the sky.

There was no sign of the cubs. No tiny tracks in the mud, no faint, telltale cries among the distant birdcalls.

Had she lost this litter, just as she had lost her last one?

After some time, the mahout urged his elephant back from the tigress. He splashed across the stream, then along the bottom of the hillside.

The sun was high now, the forest silent.

We started climbing; the mahout's eyes were fixed on the hillside.

He stopped, smiled, and pointed upward through the leaves. It took me a moment to spot the three cubs the size of cocker spaniels lying on a little rock shelf perhaps a hundred feet above us. The two females dozed, but their brother was up and alert, his big ruffed head and his paws out of all proportion to his body. His bright eyes looked right past us, focused on his mother far below, waiting for her signal to clamber down the hill and eat.

Here at Bandhavgarh—and in every tiger forest where there remains enough to eat and human intruders are kept at bay—the life cycle of the great cats continues. Watching and listening, I remembered something Dale Miquelle had said to me. "We have to find the magic formula that allows man and tiger to coexist. That's not a dreamy goal. Finding it may be the key to man's survival as well. After all, we share the same ecosystem. If we can't save the most magnificent animal on earth, how can we save ourselves? I don't believe the tiger's cause is hopeless," he continued. "At least it's no more hopeless than our own."

I returned to India several months later

to take another look. Sita and her cubs still flourished in the heart of Bandhavgarh, but Charger, *(continued on page 54)*

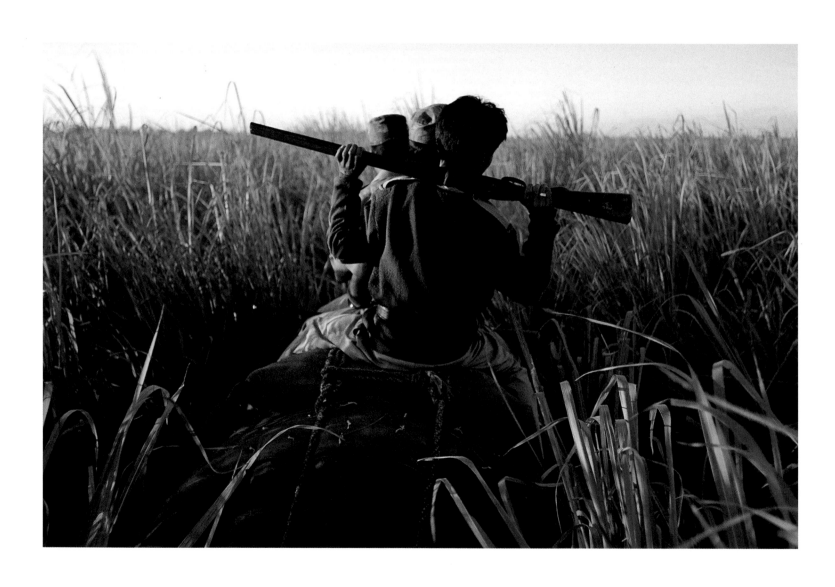

At Kaziranga National Park in Assam, armed forest guards on elephant-back patrol against
rhino poachers (opposite), prepared for shoot-outs that have taken lives on both sides.

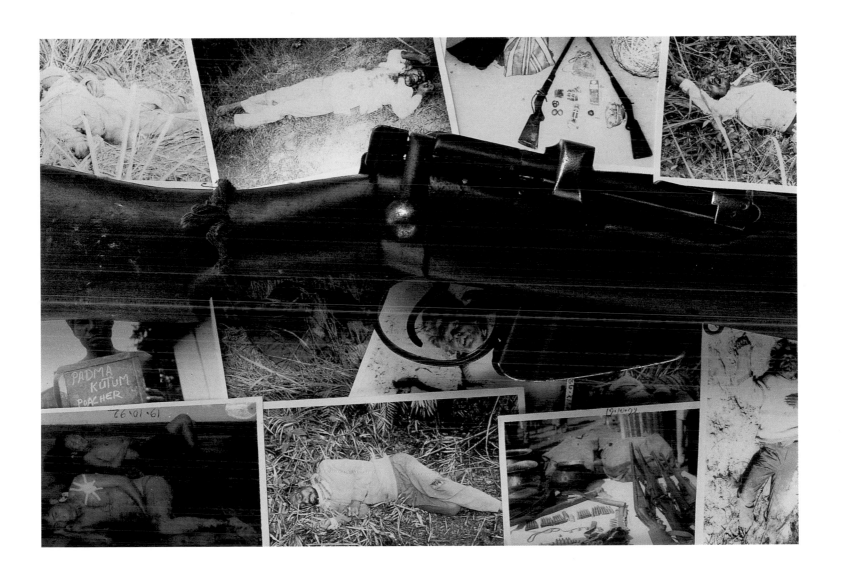

thought to be the father of her last three litters, was at last said to be fading from the scene, badly battered after a series of encounters with a younger male eager to take over his territory—and his tigresses.

But it was as clear as ever that the battle to save the tiger would have to be waged reserve by reserve, sanctuary by sanctuary. In the north there had been a rash of tiger poisonings by vengeful villagers whose livestock had been taken by predators that had strayed beyond the borders of two parks—eight tigers were lost in just two months—and the decline in poaching had proved short-lived: The number of seizures of skins and bones actually rose in 1997. But word also came from Hong Kong that conservationists and practitioners of Chinese traditional medicine were holding serious discussions about finding workable substitutes for tiger products: A blend of bones from deer and dogs was said by one pair of researchers to yield the same alleged analgesic and anti-inflammatory effects as the real thing, and plans were under way to test it further.

Indian national elections displaced many of the members of parliament who had demanded that tiger protection be improved—as well as the prime minister they had urged to act—so that in the end nothing concrete had been accomplished. "The signature campaign did set a historical precedent as an expression of political will," Valmik Thapar told me. "Government still plays a critical role. We can't stop trying to make it do better. But it's also clearer than ever that it will take more than government alone to save our forests. We need help from ordinary people everywhere, overseas as well as here at home."

At Bhadra, a tiger had recently been killed by an explosive device buried in the carcass of a village cow, but Wildlife First had managed to get the commercial harvesting of the park's bamboo stopped; the sanctuary itself was soon to be designated part of Project Tiger; and three jeeps provided by Global Tiger Patrol were in use on forest roads and more were on their way from the Karnataka Tiger Conservation Project, funded largely by the Wildlife Conservation Society, and the Save The Tiger Fund. And discussions aimed at transferring Bhadra's dissatisfied villagers to comparable lands outside the park, where they would be able at last to enjoy the material benefits for which they longed, had begun.

And at Ranthambhore, where poaching and poor management had seemed to signal sure disaster, the news was good again. A new man was now in charge, a soft-spoken but tough-minded south Indian named G. V. Reddy determined to defend his tigers against all odds. He managed to reinvigorate the once demoralized staff and during the monsoon—when even the sere Ranthambhore jungle turns lush and green and graziers traditionally invade the park to fatten their herds—he personally led his men into the field. In a series of confrontations, he managed to hold the line for the first time in years. Reddy's firmness provides no permanent solution to Ranthambhore's problems; only some sort of enduring peace between the park and the people who live around it can accomplish that. But it has bought more precious time, and, for the moment at least, Ranthambhore seemed to be undergoing a renaissance.

Fateh took me into the park again. We stopped for a time alongside several other jeeps filled with jostling tourists to peer through the thorny undergrowth at three cubs gamboling around their sleeping mother.

Then we drove farther into the forest, where everyday visitors are forbidden to go.

The dusty track turned stony as we started downhill between the high walls of a dark, narrow canyon.

Suddenly Fateh put on the brakes. Above us crouched two adolescent cubs, one male, one female, just months away from the moment when they would leave their mother's side and strike out to claim territories of their own. The tigress was a little farther down the hillside, utterly unconcerned by our presence, her orange coat aglow against the black rock as she pinned down the shoulder of a chital stag with one massive paw and tore strips of meat from it with her teeth. The forest was silent except for the cracking of bones that echoed and re-echoed from the canyon walls, just as it must have done for thousands of years, just as one hopes against hope it will for thousands more.◗

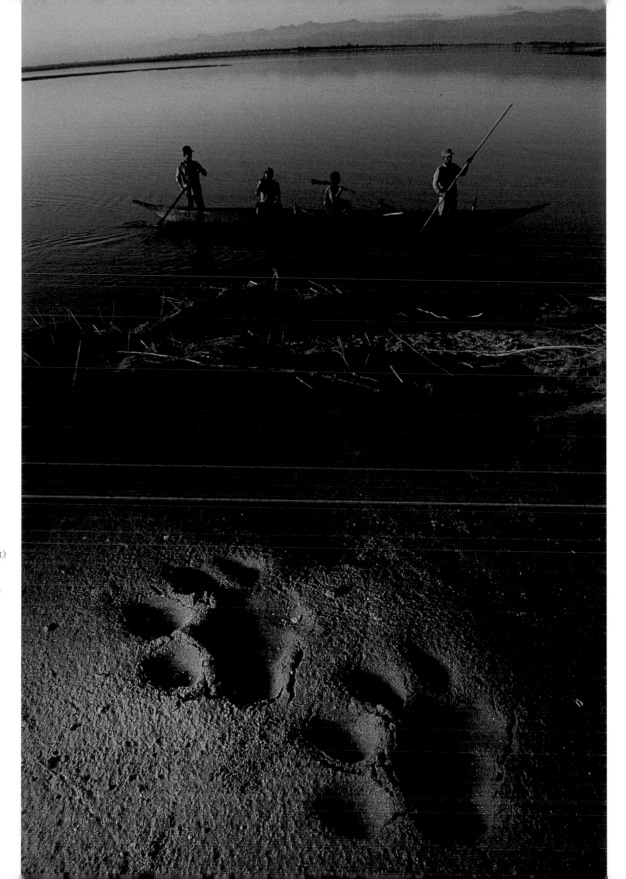

A forest department patrol (right) poles its way past a tiger's pug-mark on the muddy bank of the Brahmaputra River.

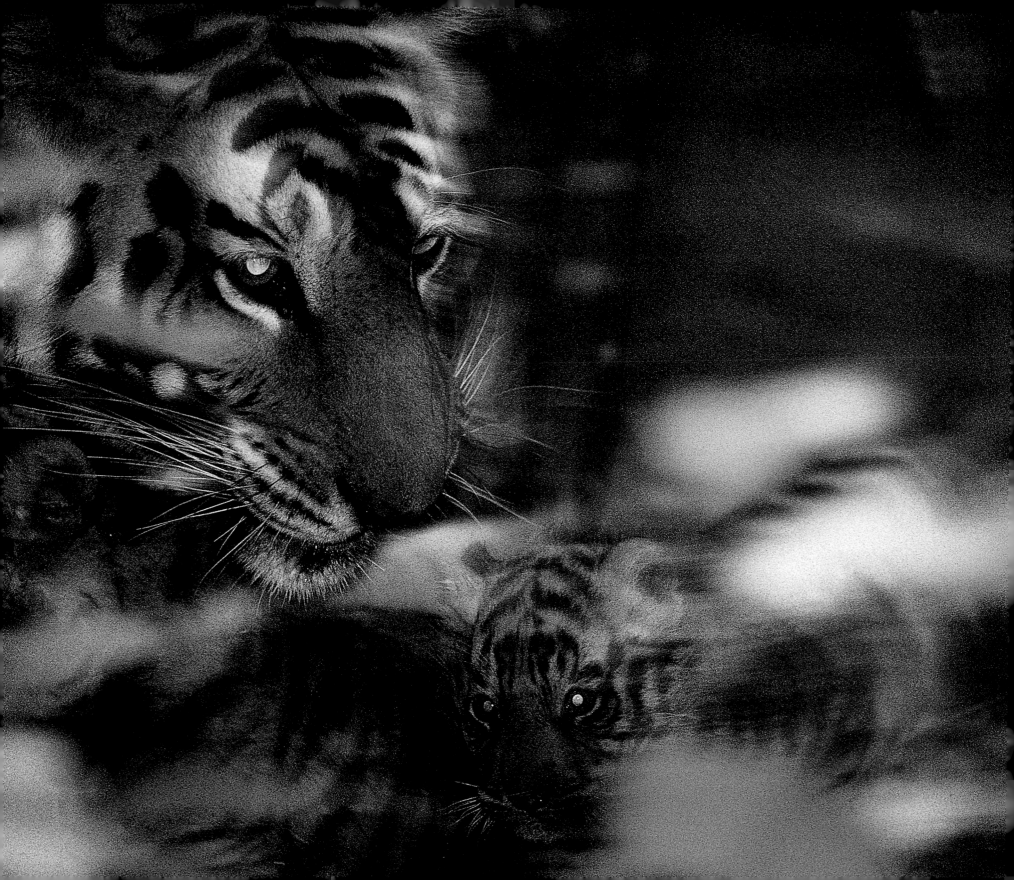

The tiger is the finely tuned product of millions of years of evolution. It is the largest of the great cats, a massive, powerful predator ideally suited to ambushing and killing prey several times its own size, and it is the unchallenged sovereign of the forests and grasslands over which it reigns. But it is also surprisingly vulnerable: Up to half of the tiger cubs born in the wild do not live to reach maturity, and of those that do grow up, fewer than half ever manage to establish a territory or breed young of their own.

To ensure the survival of the species then, tigresses like Sita must take extraordinary measures to safeguard their young. They begin by choosing the most secluded spot they can find in which to give birth. Cubs are born blind and helpless, and for two months thereafter remain utterly dependent on their mother's milk. During this period they are defenseless against a host of natural enemies—hyenas, wild dogs, leopards. Even a passing male tiger can be a threat if the cubs do not happen to be his own. To minimize the dangers, tigresses keep their offspring carefully hidden, gently moving them to a new hiding place whenever they feel a place has been too much disturbed.

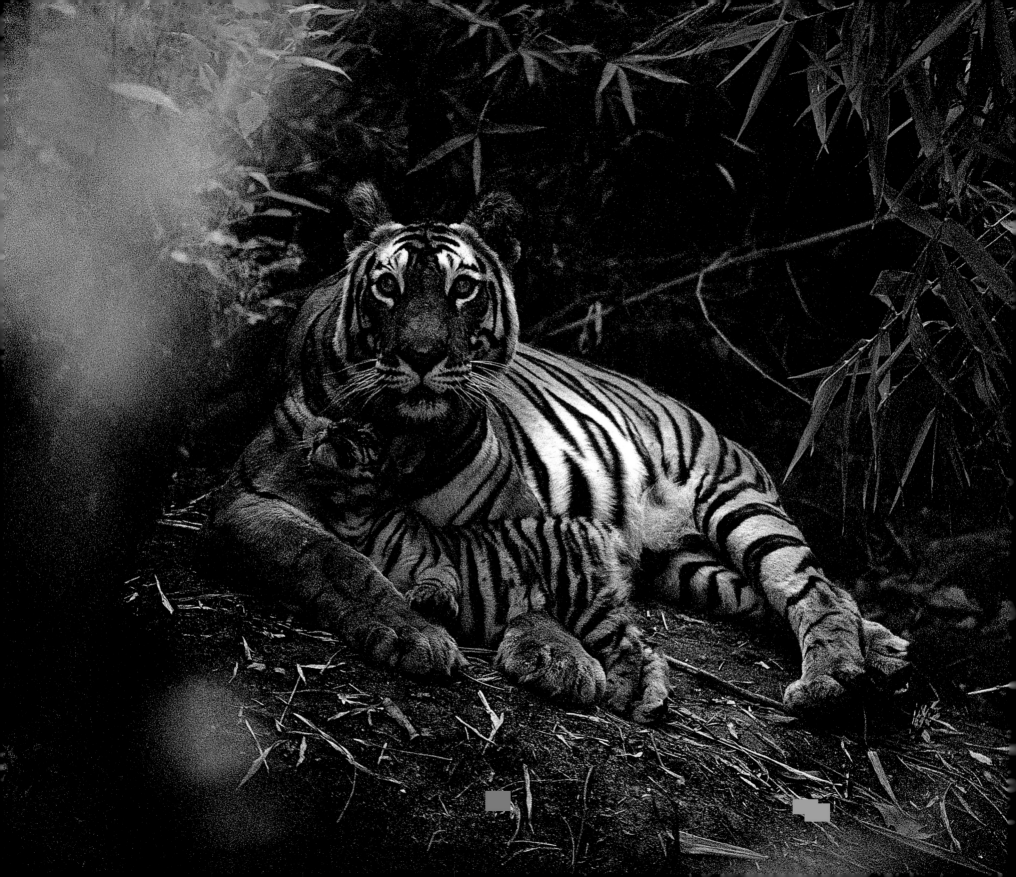

Deep in the heart of the
Bandhavgarh forest, Sita
shelters one of her three
two-month-old cubs.

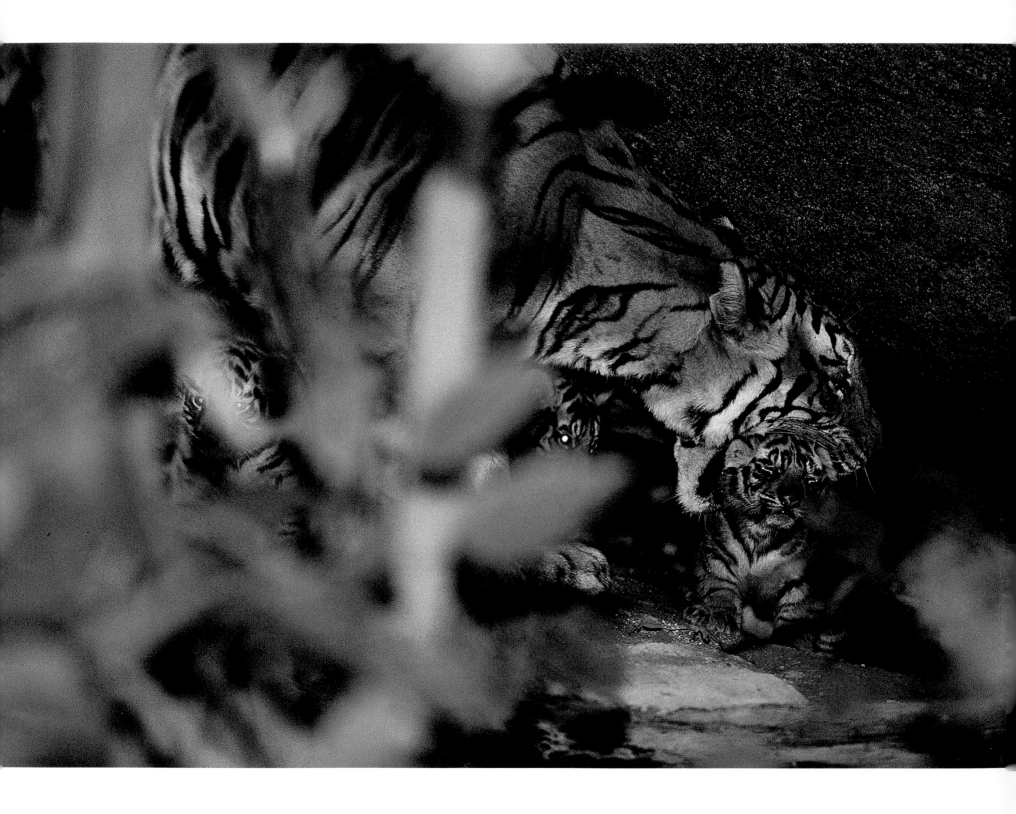

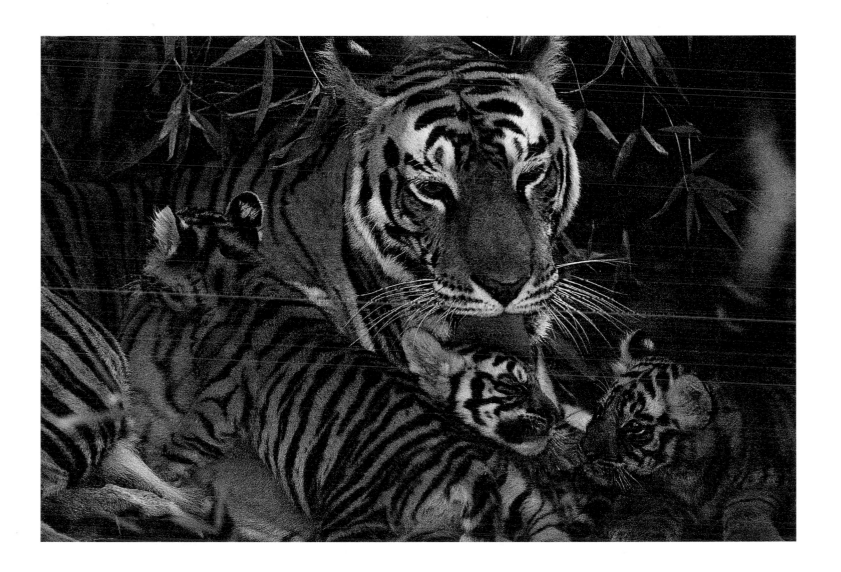

Sita ensures that her cubs remain safely hidden when she is not around to feed and groom them.

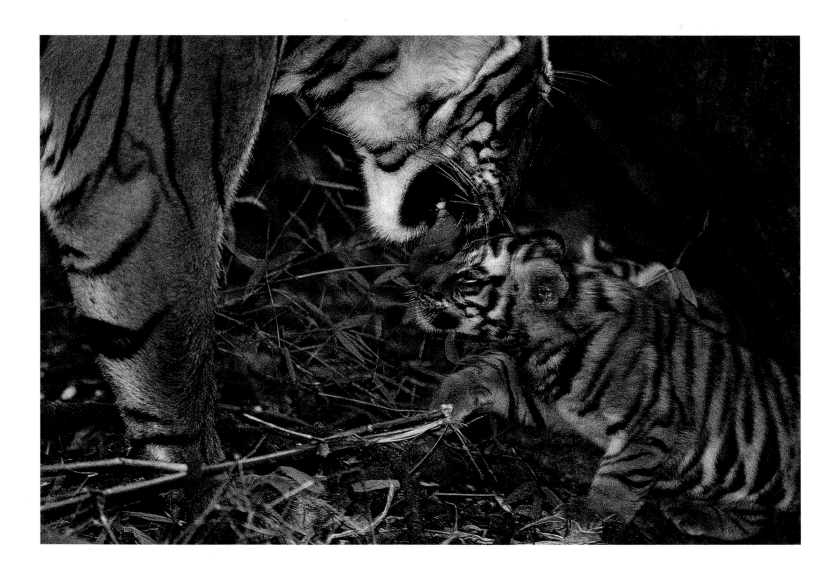

Back from the hunt, Sita urges her cubs to emerge from their hiding place.

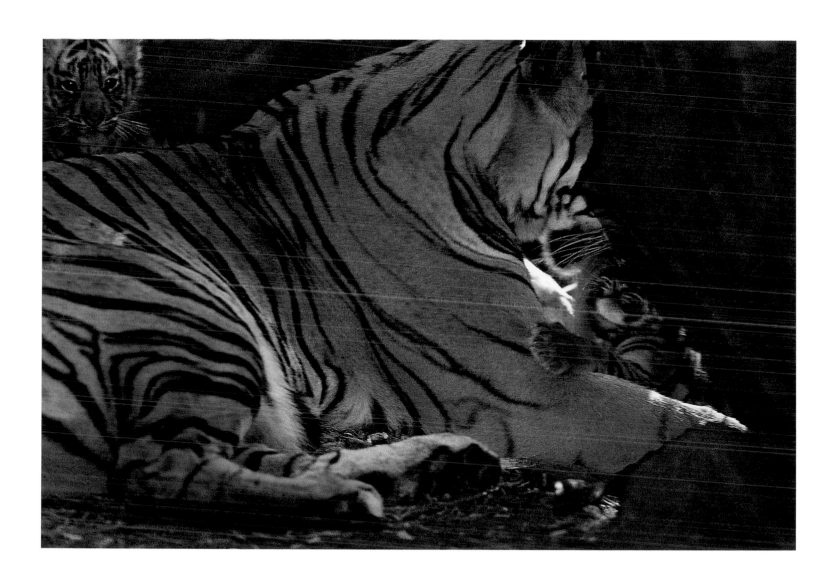

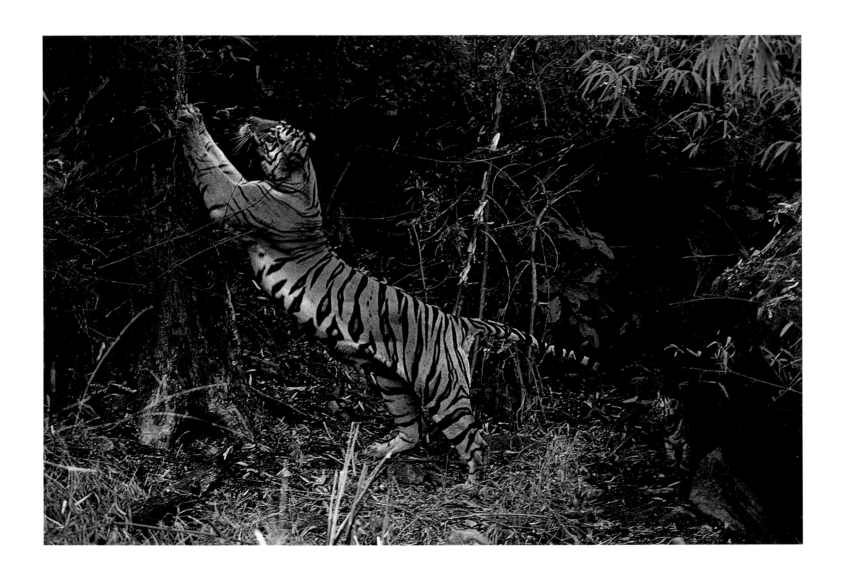

Before setting off once again in search of food, Sita marks her territory with her claws under the watchful eyes of one of her offspring, then shoos the cub back into its lair where it will stay until she returns.

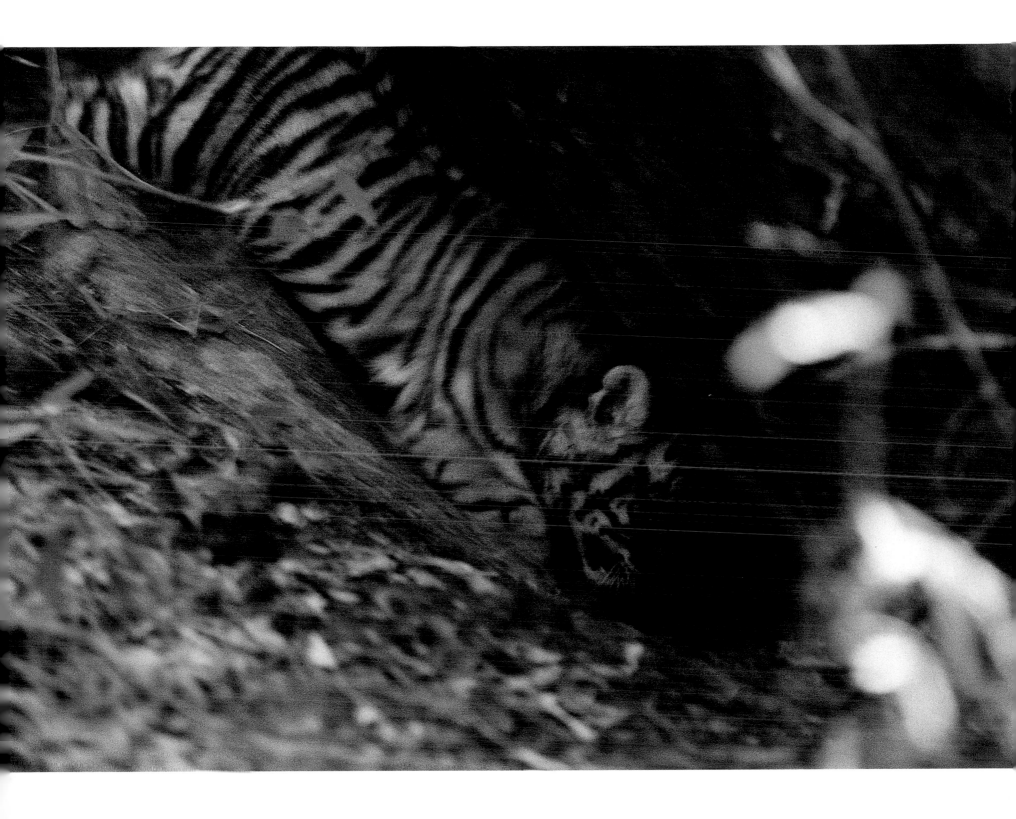

Sita, home between hunts
just long enough to
nurse and rest, greets one of
her hungry young.

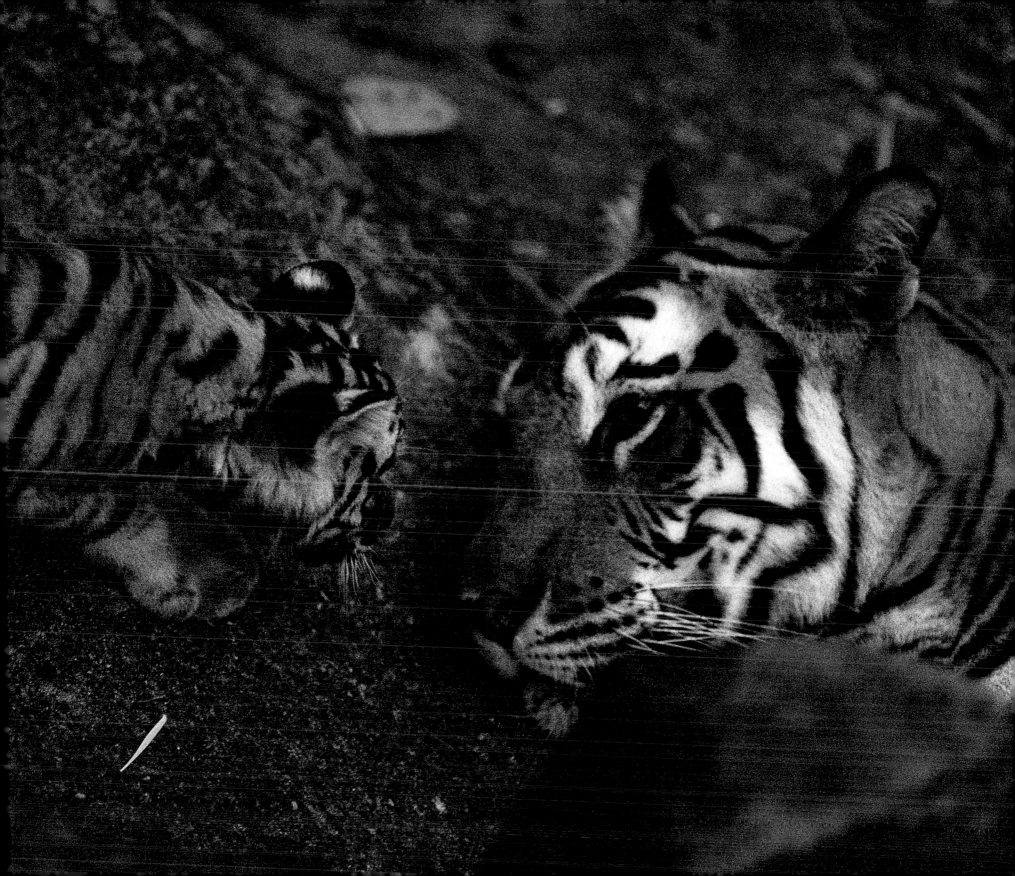

Intruders into the Indian tigers' world now include thousands of tourists, foreign and domestic, every year. Hotels and lodges have begun to proliferate around India's best known parks, yielding handsome profits for tour operators and city-based entrepreneurs, but often straining precious supplies of water and power. The fast-growing Indian middle class has begun to show a heartening interest in conservation, but regulations meant to control the behavior of visitors in the forests are often ignored in the interest of spotting a tiger at all costs. Meanwhile, schemes by which tourism can directly benefit the people actually living around parks and sanctuaries have yet to materialize in India, and the presence of affluent strangers inside forests from which poor local people are barred by law remains a source of dangerous resentment, a continuing threat to the survival of the subcontinent's remaining wild places.

On the lookout for Sita and her cubs, elephants ferry visitors back and forth across the Bandhavgarh landscape.

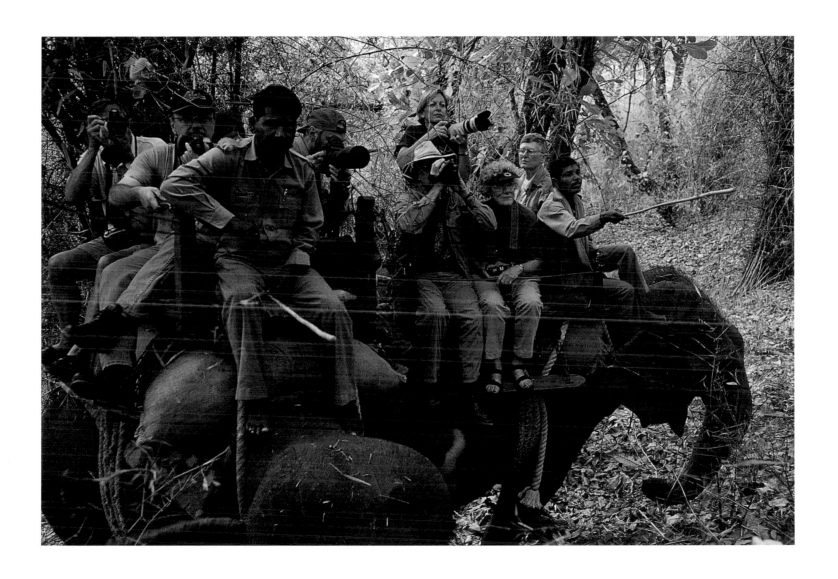

Dutch wildlife enthusiasts zero in
on their targets from the safety of
their jeeps. Tigers in some forests
seem virtually oblivious to visitors,
provided they remain in vehicles
or on elephant-back.

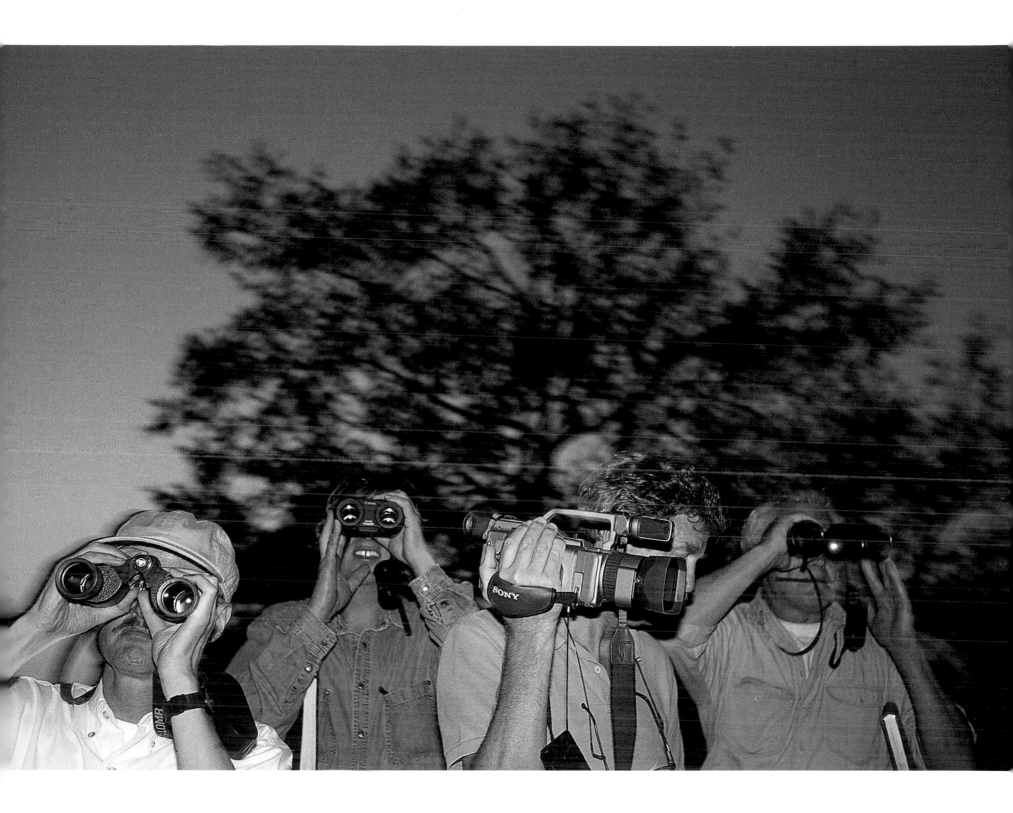

Charger, Sita's mate, reacts
to a jeep that got too close.

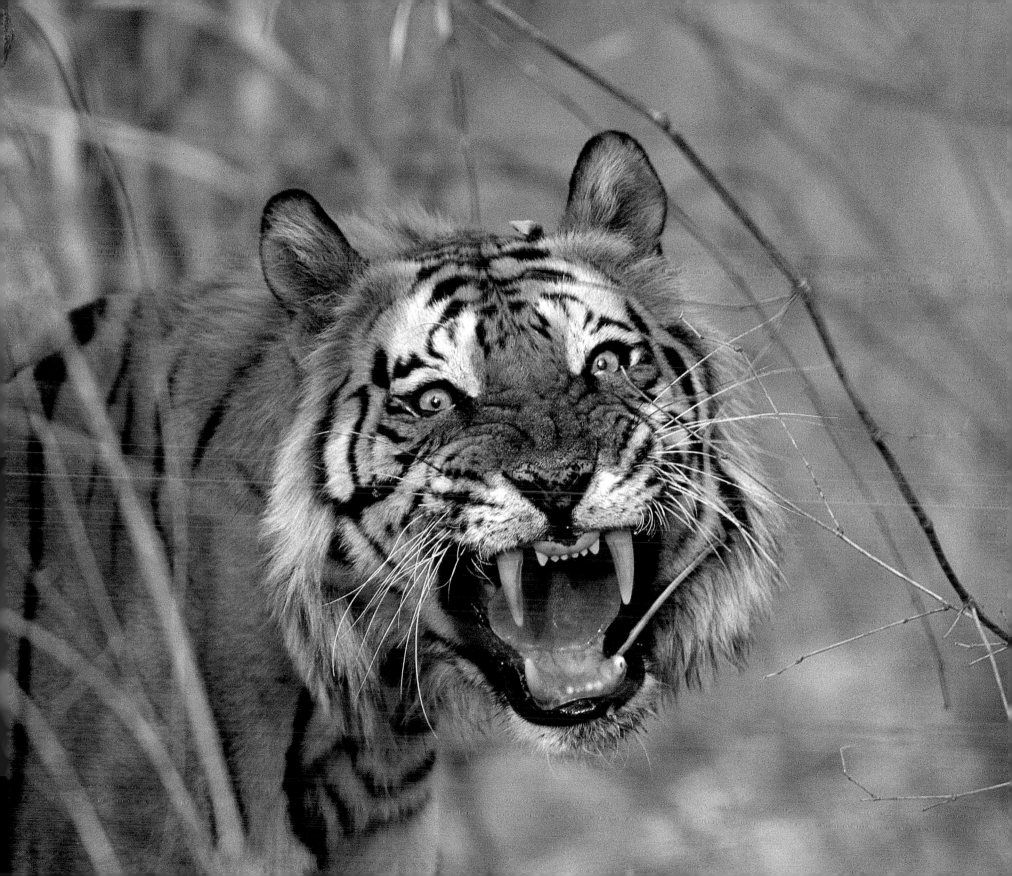

"There is nothing freer than a wild tiger on the loose," wrote the American tiger expert Charles McDougal, and "there are few things more tragic than a tiger behind bars." The big male on the opposite page was once wild. One of India's "forgotten tigers" that somehow manage to survive outside protected areas, he simply appeared one night within Madhav National Park in Madhya Pradesh where there were supposed to be no tigers. He was lured to leap into an enclosure over a supposedly unclimbable fence by the presence of a cluster of young females. In the process, he injured himself so badly that he can never be released again and will live out his life behind bars.

No one knows for certain how many tigers currently live in captivity. The conditions under which they are kept range from cruel to comfortable. Some are over-grown house pets. Others are made to provide entertainment and profits for their owners.

Meanwhile, in well-run zoos, captive tigers serve as what John Seidensticker, curator of mammals at the Smithsonian's National Zoological Park, calls "ambassadors for wild tigers . . . living, breathing, roaring" stand-ins for their free-living cousins. The best zoos also meticulously oversee the breeding of their tigers to ensure that if the battle to save the wild tigers' world is finally lost, the species itself will not become extinct.

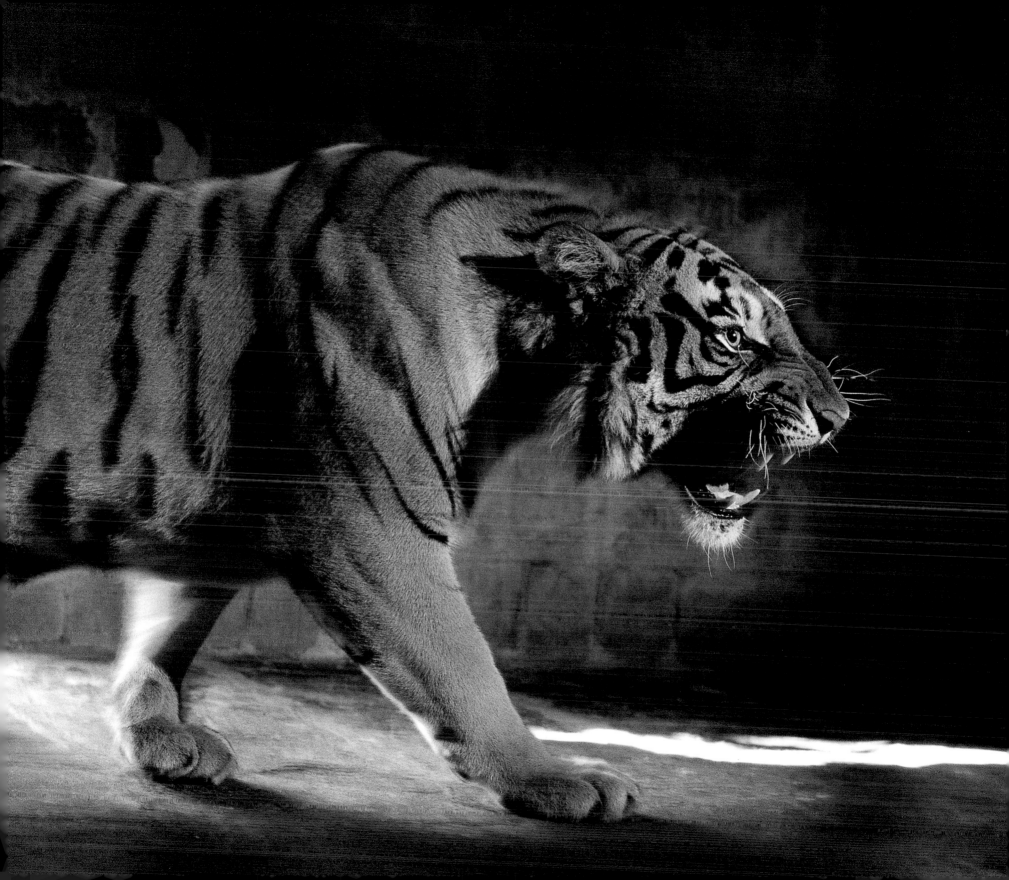

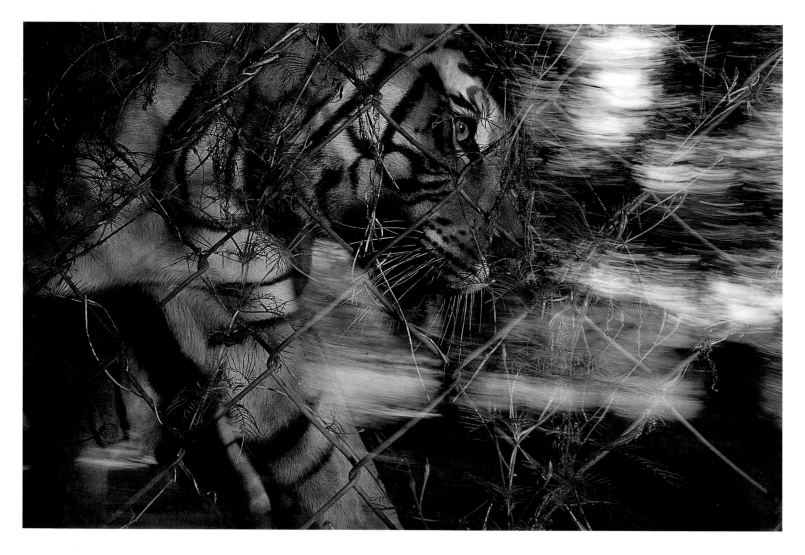

Captive tigresses, offspring of wild-caught parents, pace their enclosure at Madhav National Park. Products of a failed captive-breeding program begun by the erstwhile local maharaja, they have never been trained to stalk wild prey and therefore cannot be released into the wild for fear they will harm domestic livestock or human beings.

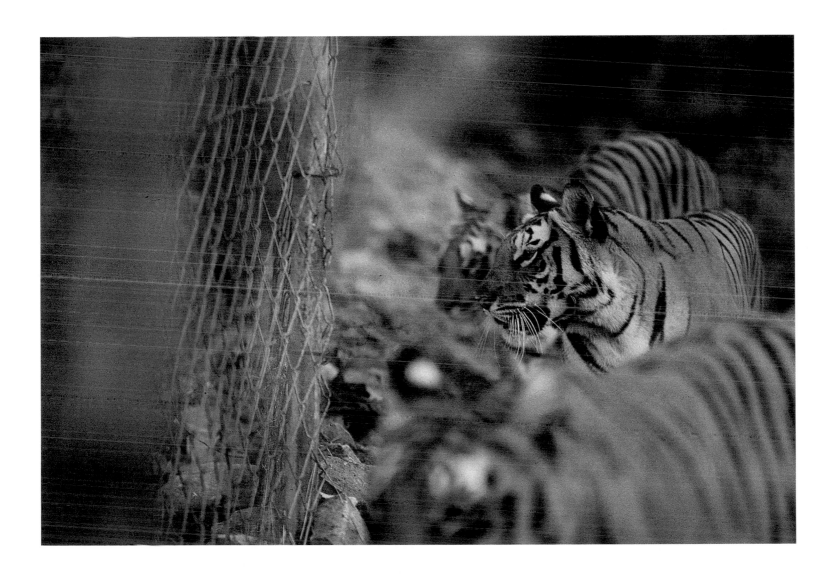

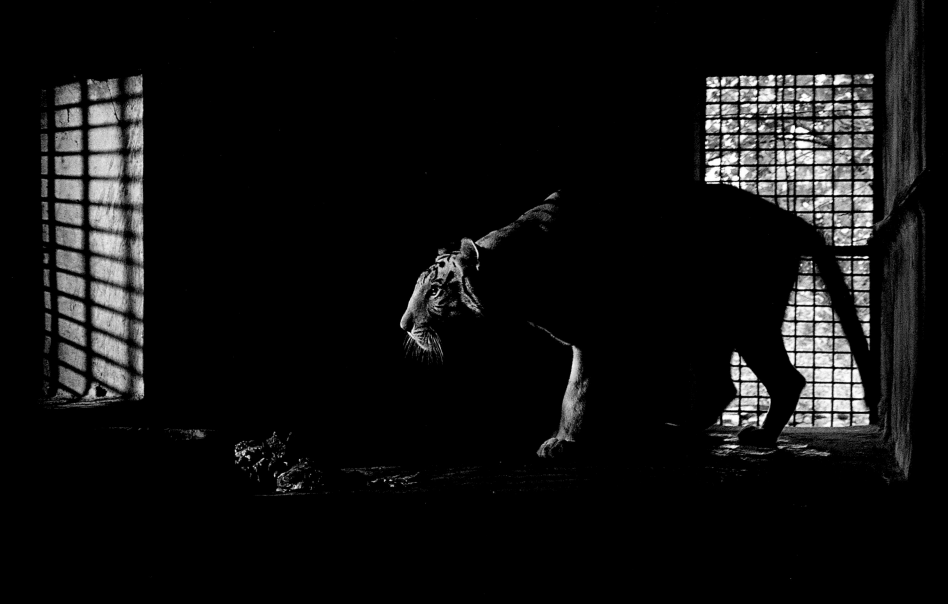

A male white tiger—neither a
separate subspecies nor an albino
but an ordinary tiger with a deficiency
of dark pigment in its coat—endures
life in a zoo in Bhopal, the capital of
Madhya Pradesh.

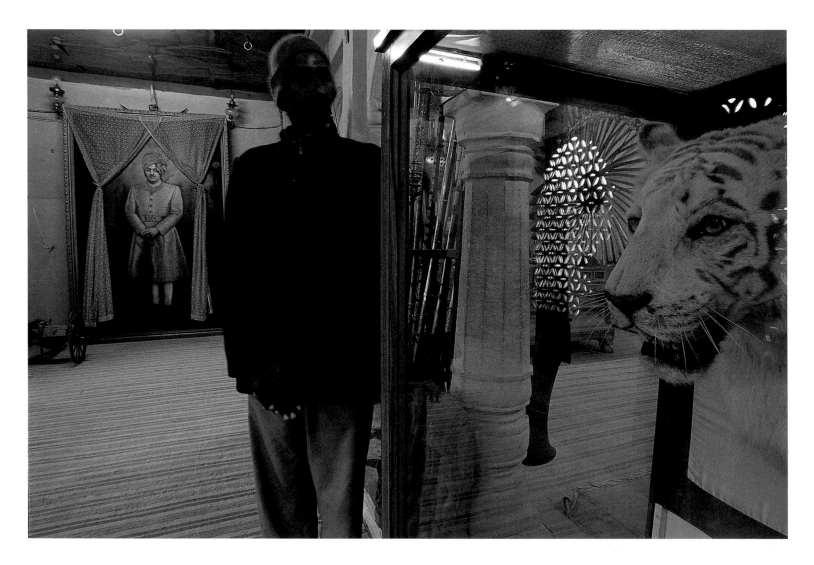

All white tigers are said to have descended from Mohan (above), captured near Bandhavgarh in 1951, bred, and subsequently stuffed for the private museum of the maharaja of Rewa. Tiger fancier Roy (opposite), half of the Las Vegas duo of Siegfried and Roy, delights in displaying animals like the cubs that surround him. Their variegated coats may look elegant onstage, but geneticists consider such animals' bloodlines useless for maintaining healthy captive populations of distinct subspecies.

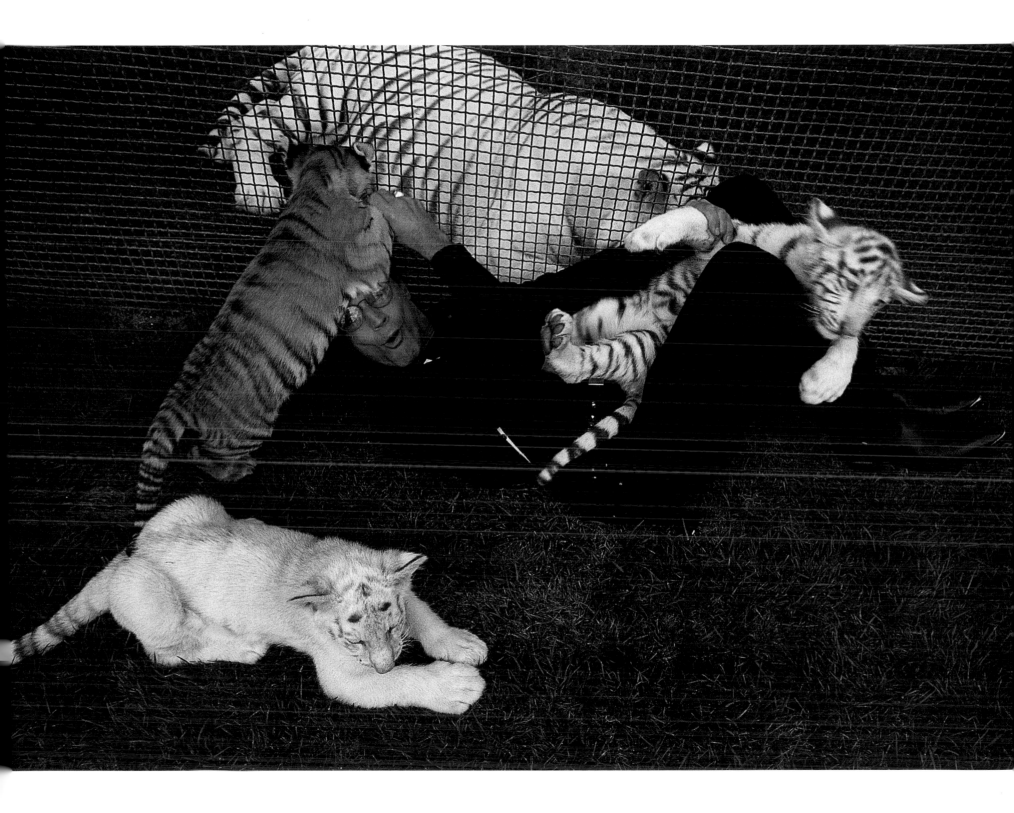

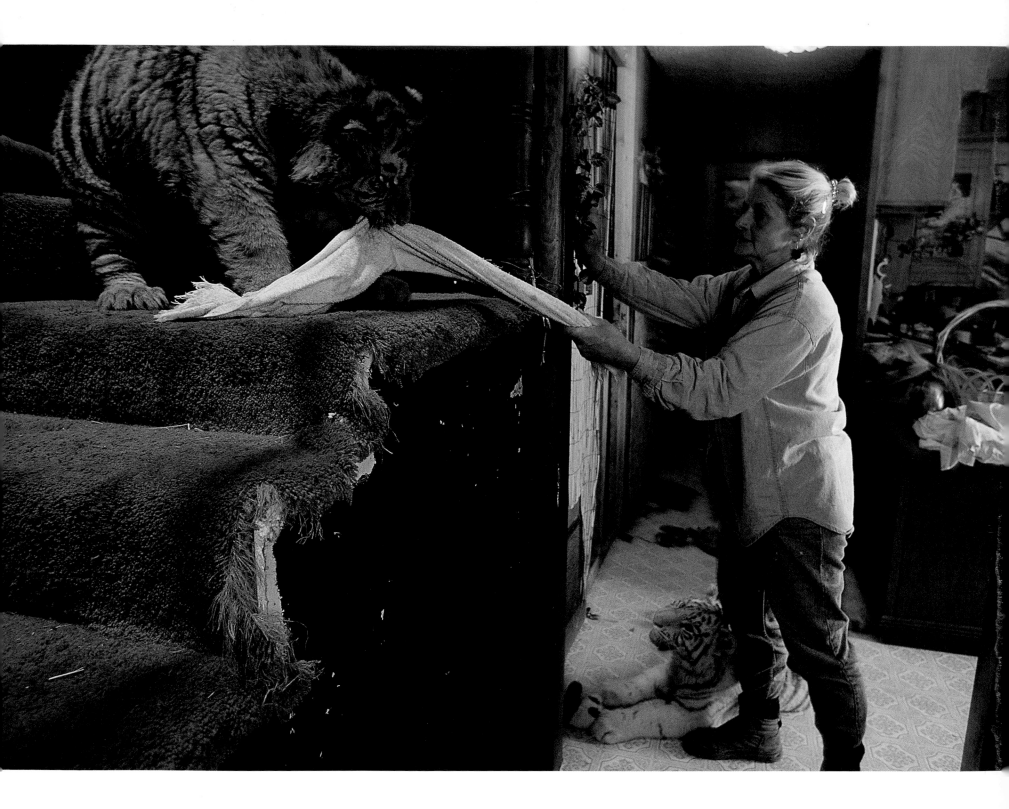

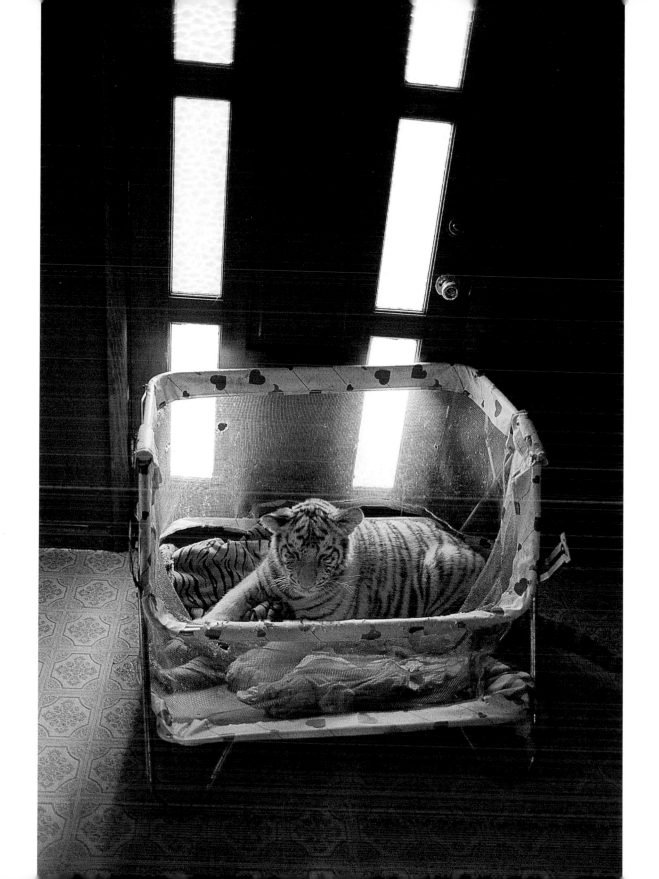

Betty Young, an Arkansas tiger enthusiast, presides over a private menagerie of more than 50 tigers. Despite their numbers, she continues to let her tigers mate. The cub Major Bill (right) regularly slept in her bed despite a propensity to snore.

85

Most of Betty Young's tigers were discarded by unthinking owners who found 400-pound pets that can demand some 5,000 pounds of raw meat a year too much to handle.

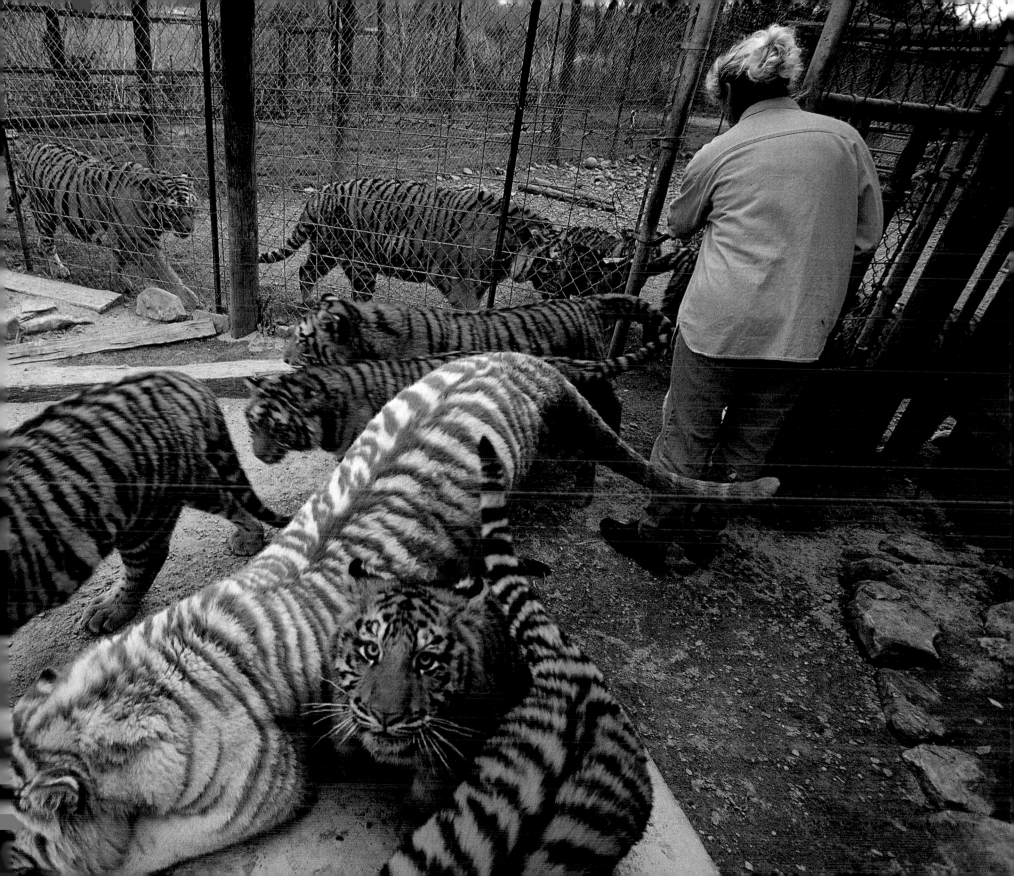

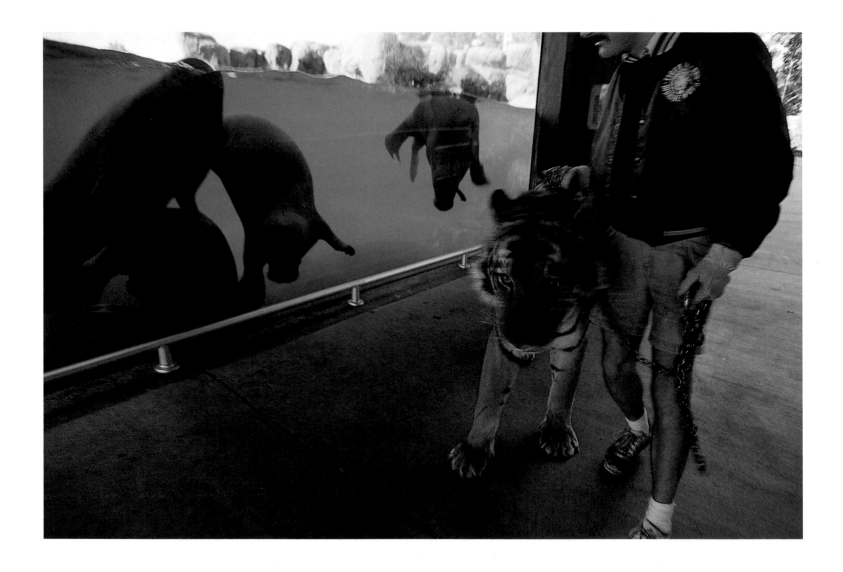

To improve the quality of life for their captive tigers, trainers at Marine World in Vallejo, California, encourage their charges to establish artificial territories for themselves. These young tigers' daily rounds include visits to a tank filled with walruses and stops at nearby trash cans (opposite).

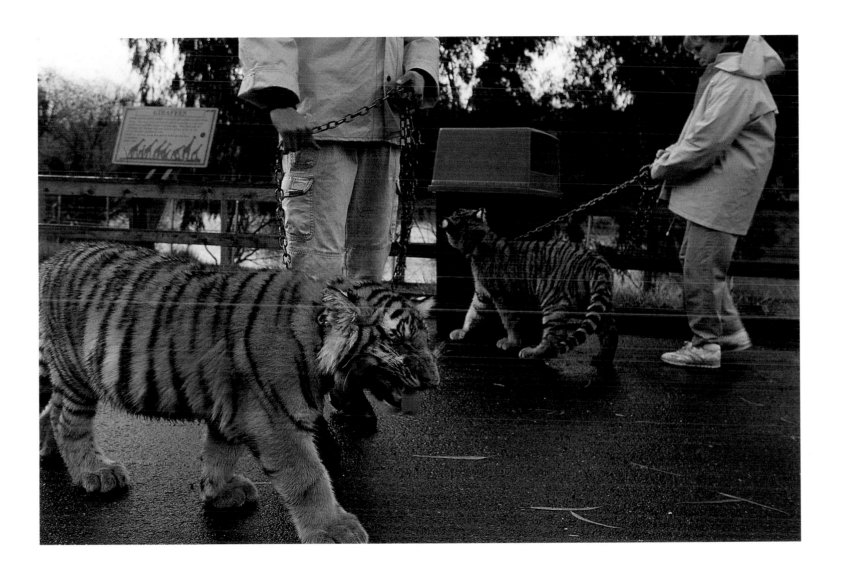

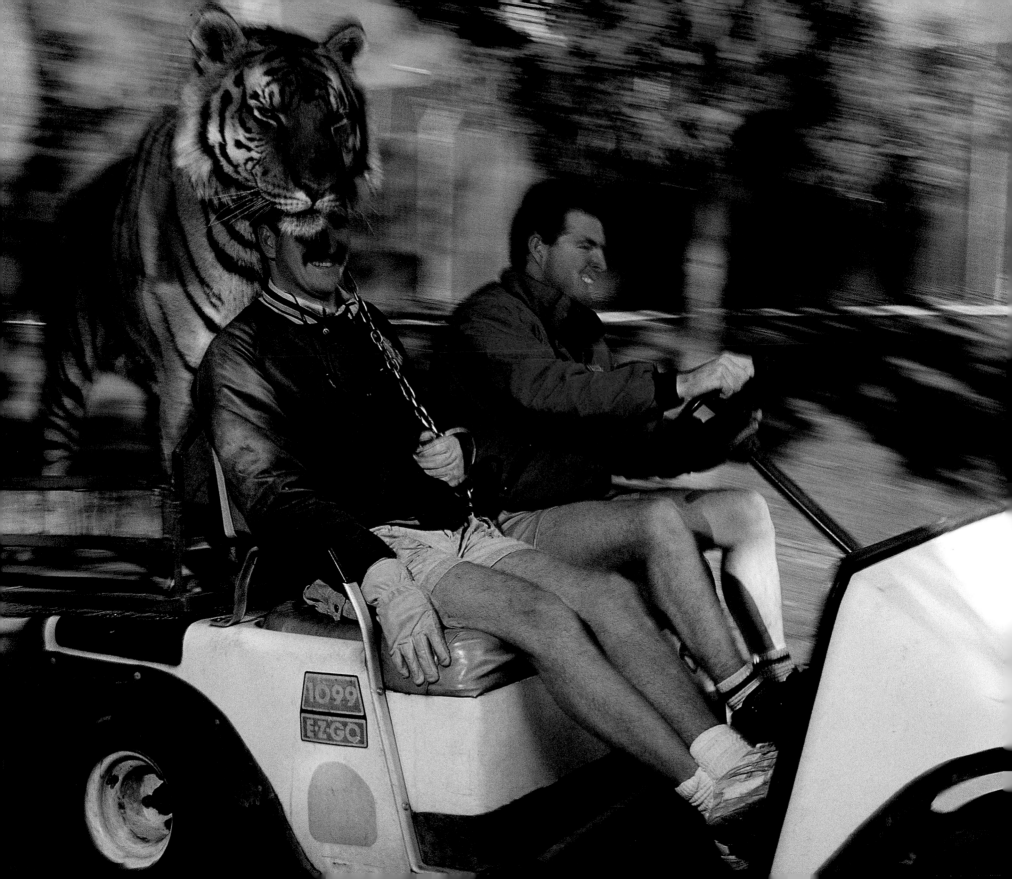

At Marine World, employees use
a golf cart to help an arthritic
16-year-old Bengal tiger named
Rakhan patrol his "territory."

A wild-caught tiger in an Indonesian zoo.

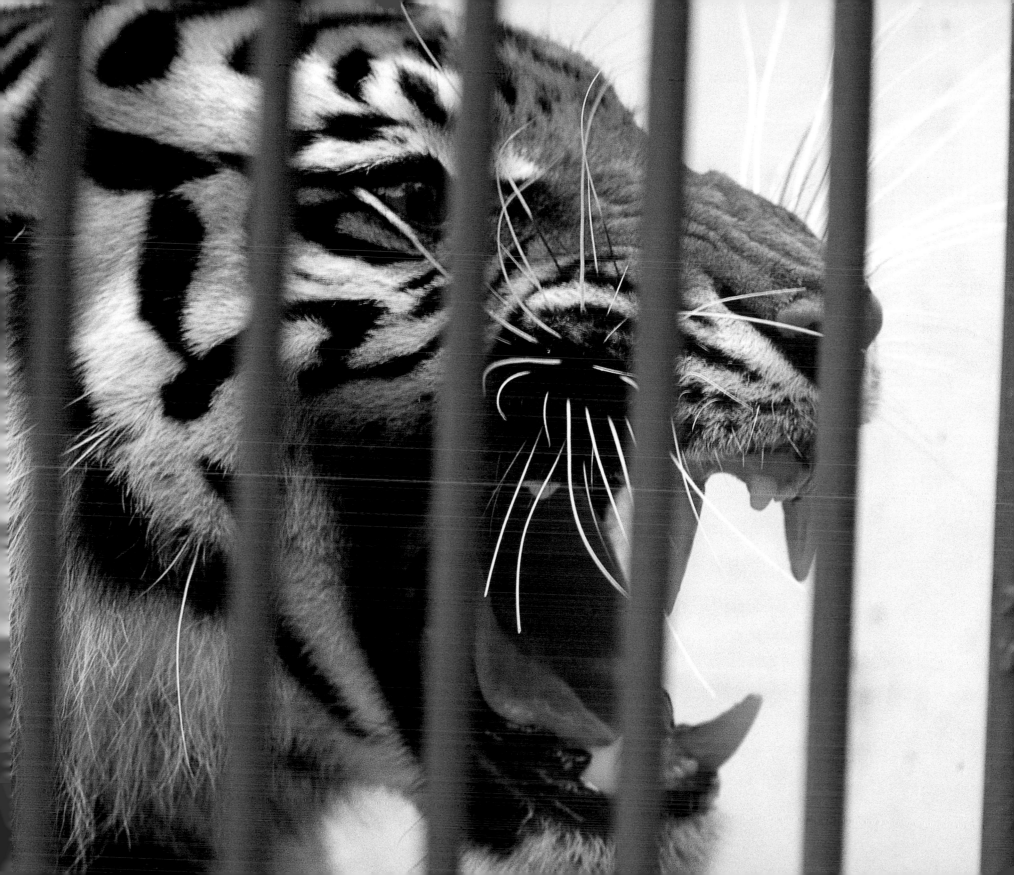

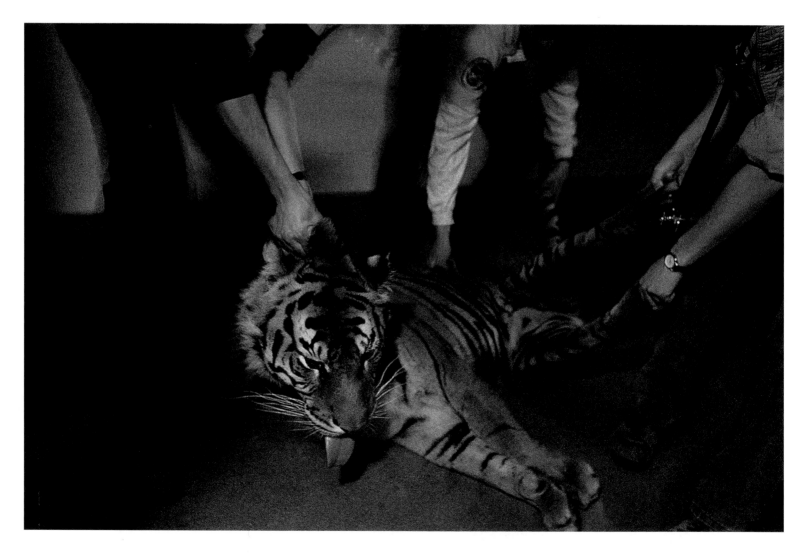

Seeking to learn all they can about tiger reproduction, veterinarians at Omaha's Henry Doorly Zoo anesthetize a Sumatran tigress and introduce semen (opposite). The procedure failed, as it almost invariably does, but scientists cling to the hope that they will one day find a way to ensure against inbreeding in the wild by introducing fresh genes from tigers living elsewhere.

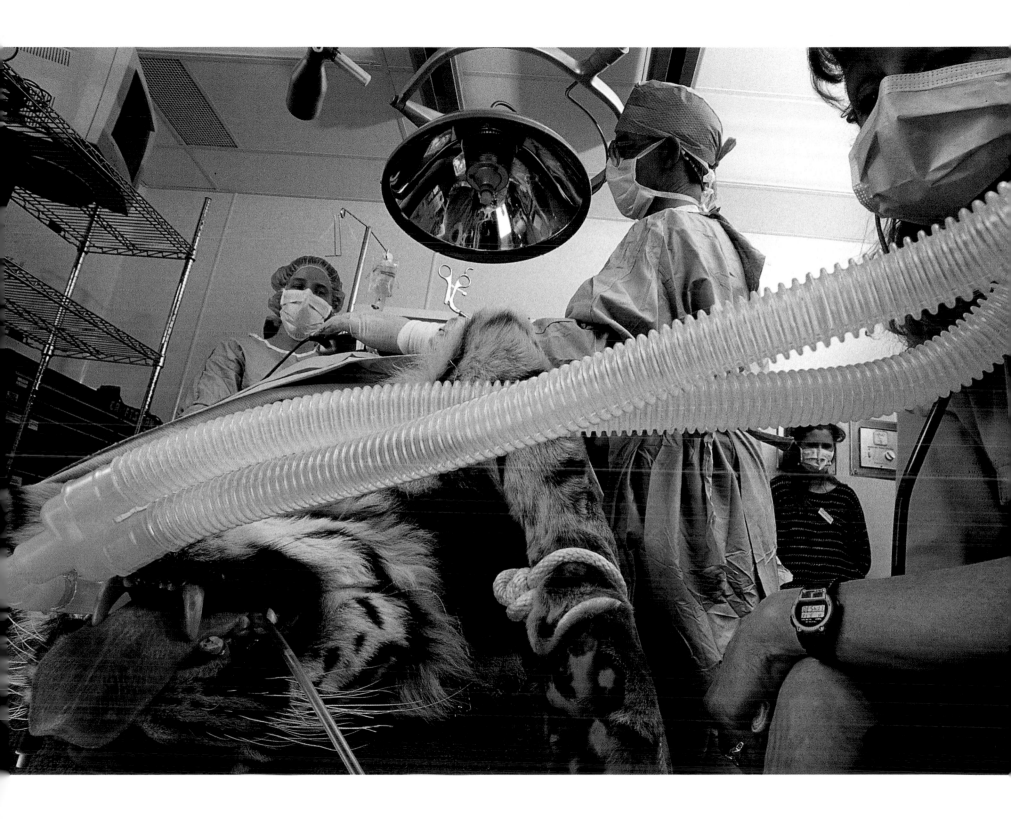

The role of the male tiger in perpetuating the species in the wild is central but also severely limited. Males sometimes share kills with tigresses and at least tolerate the presence of their own offspring, and they drive off other males that might pose a threat to them, but they otherwise play no part in bringing up their cubs. Sita's mate, Charger—shown on the opposite page frozen in mid-leap by a remote camera—drove away the father of her first cubs in 1992, seized his territory and subsequently fathered at least three more of Sita's litters. But his days as the dominant tiger are numbered. Males rarely manage to hold on to a territory for more than a few years, and he now finds himself frequently challenged by other, usually younger, males eager to take over his territory and commandeer Sita and the other breeding tigresses that make it their home.

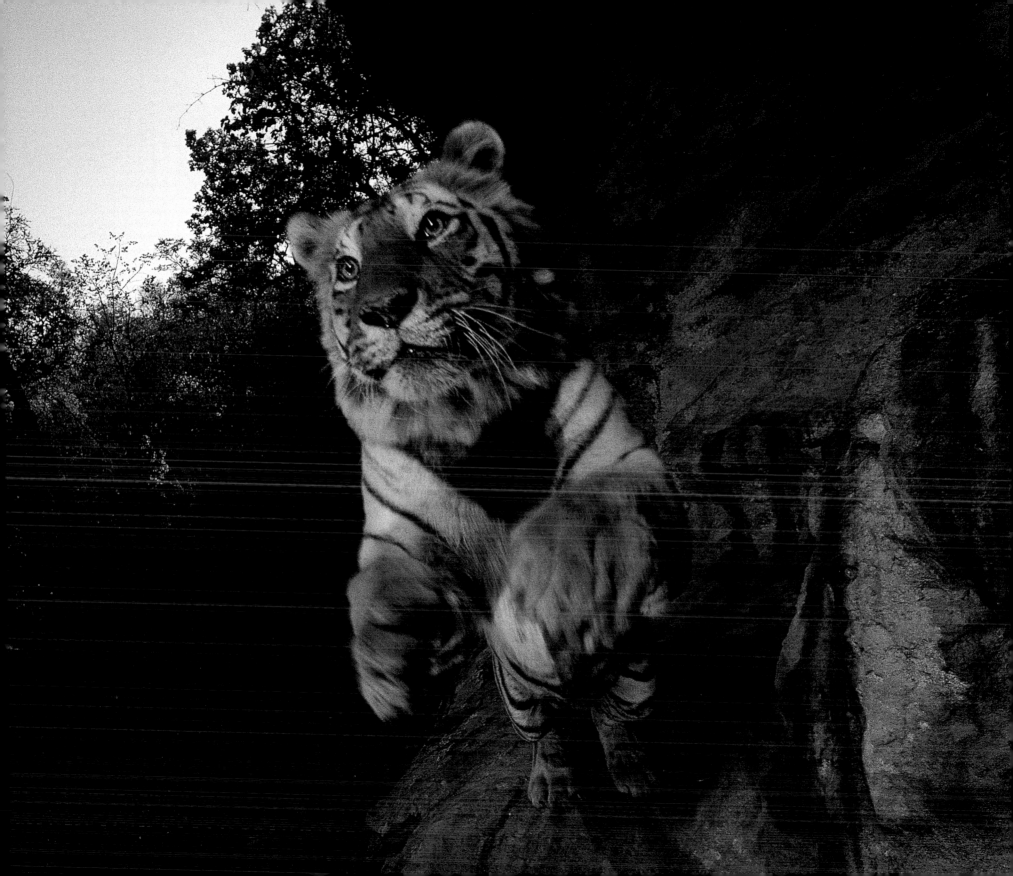

With the temperature soaring toward
120°F, Charger sits out the midday
heat in a hillside pool. Unlike most
other big cats, tigers delight in water.

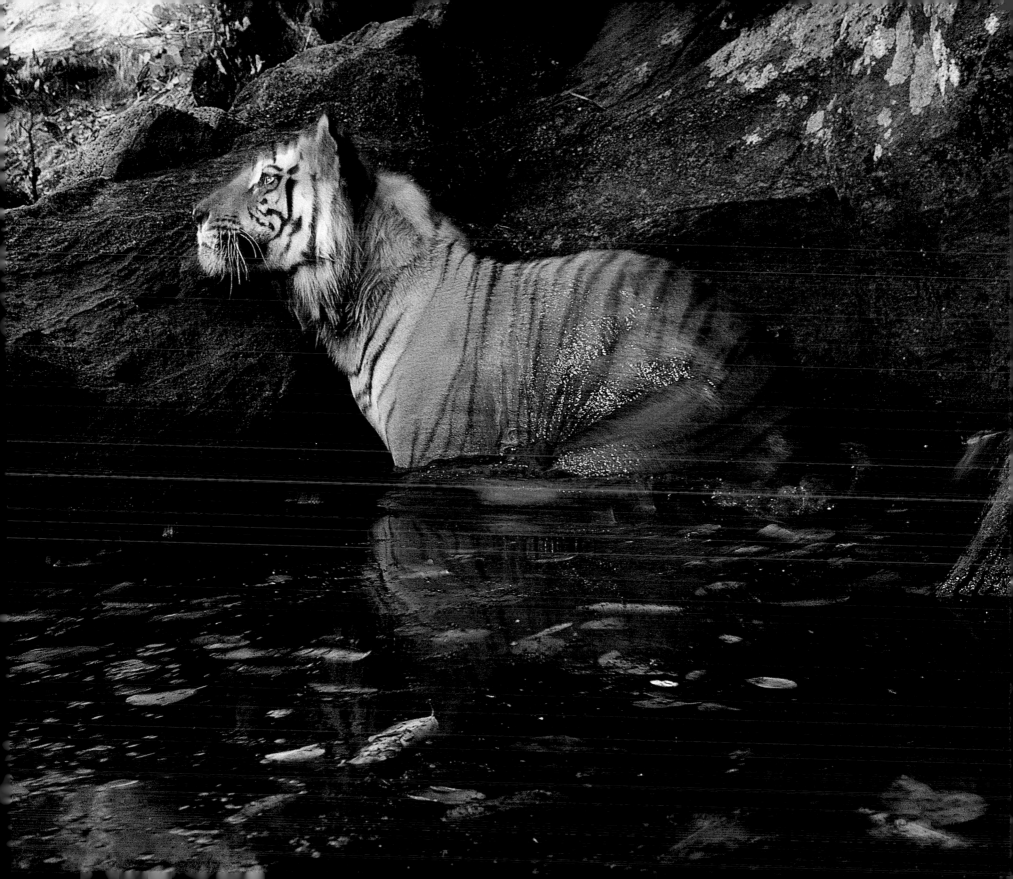

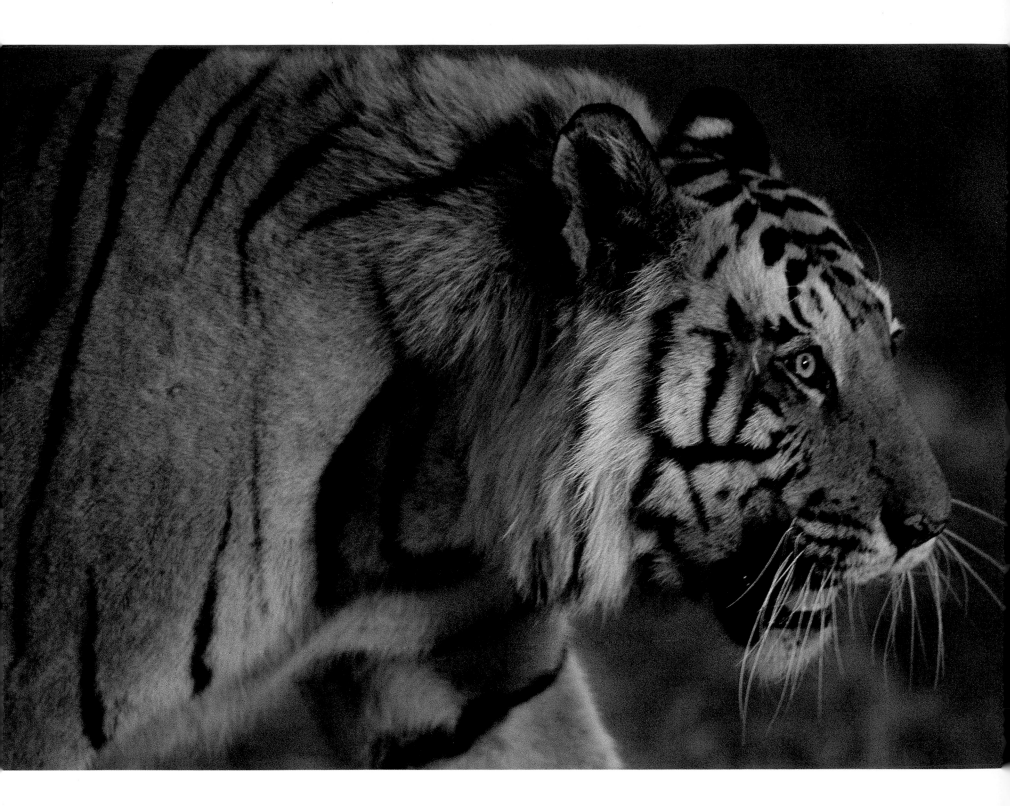

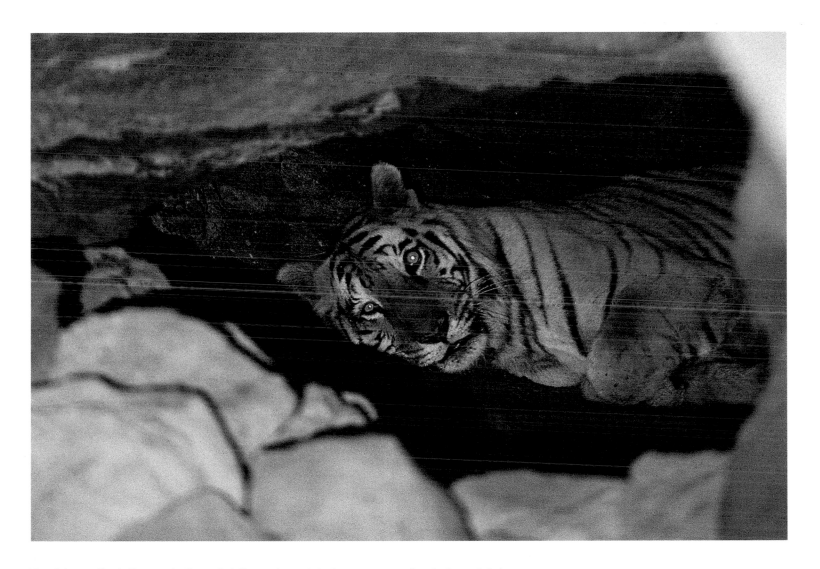

After fighting off a challenger, a badly mauled Charger (opposite) takes temporary refuge in the cool shelter of a cave where flies, attracted to his wounds, will not follow and torment him.

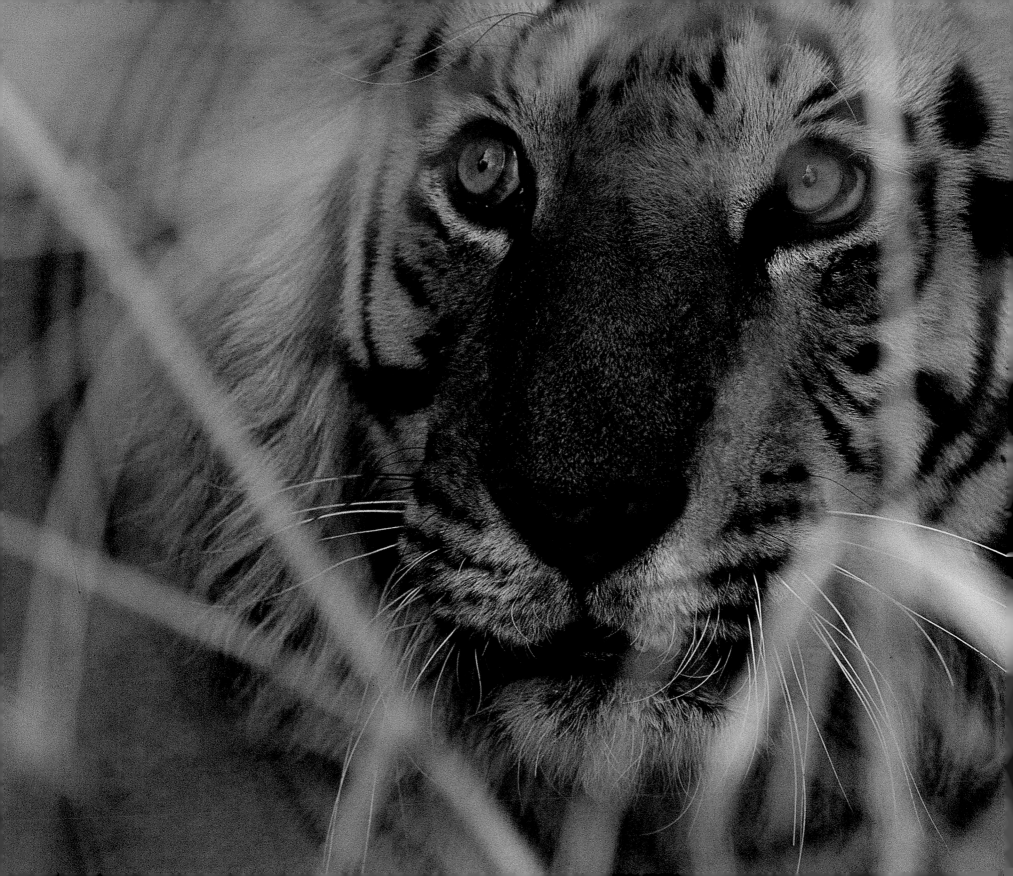

On guard against intruders, Charger
remains half hidden in the grass.

His belly full, no rivals in sight
for the moment, Charger enjoys
a wallow in the midst of the prey-
rich swamp at the heart of the terri-
tory he must constantly defend.

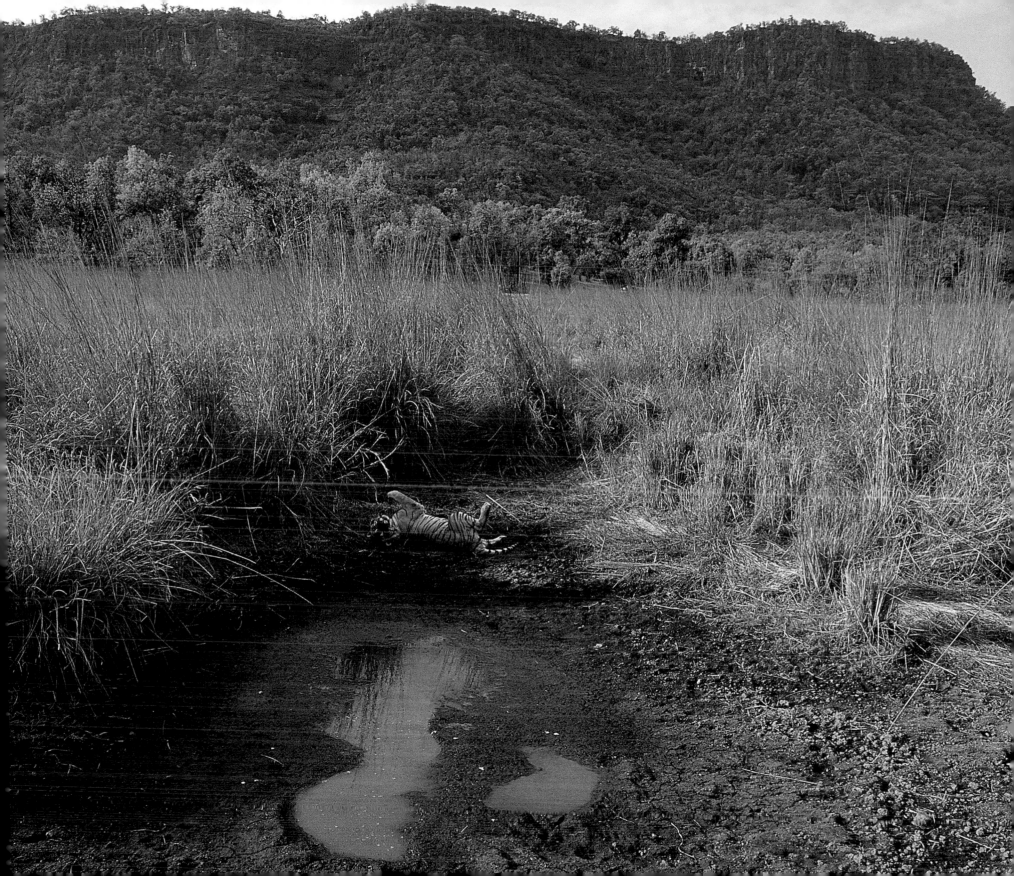

The tense but thirsty tiger on the opposite page is one of Charger's rivals; his territory overlaps with Charger's at this water hole, and when drinking each must keep a wary eye out for the other. This self-portrait—and those of the other animals and birds on the following pages—were all triggered in midsummer by remote cameras around the same pool at Bandhavgarh.

The earliest pictures of this kind were made in the early 1920s by an enterprising British forester named F. W. Champion. Despite the hard work it demanded and the cumbersome equipment Champion was forced to employ, he wrote in *With a Camera in Tigerland,* such photography "provides all the excitement of the stalk and the pitting of one's wits against those of the ever-alert inhabitants of the jungle; it requires far more knowledge and patience [than hunting with a rifle]; it gives one an inside acquaintance with the lives of the hunted in a way that shooting can never do; and, above all, it does not involve spilling the blood of creatures with which one has no quarrel…."

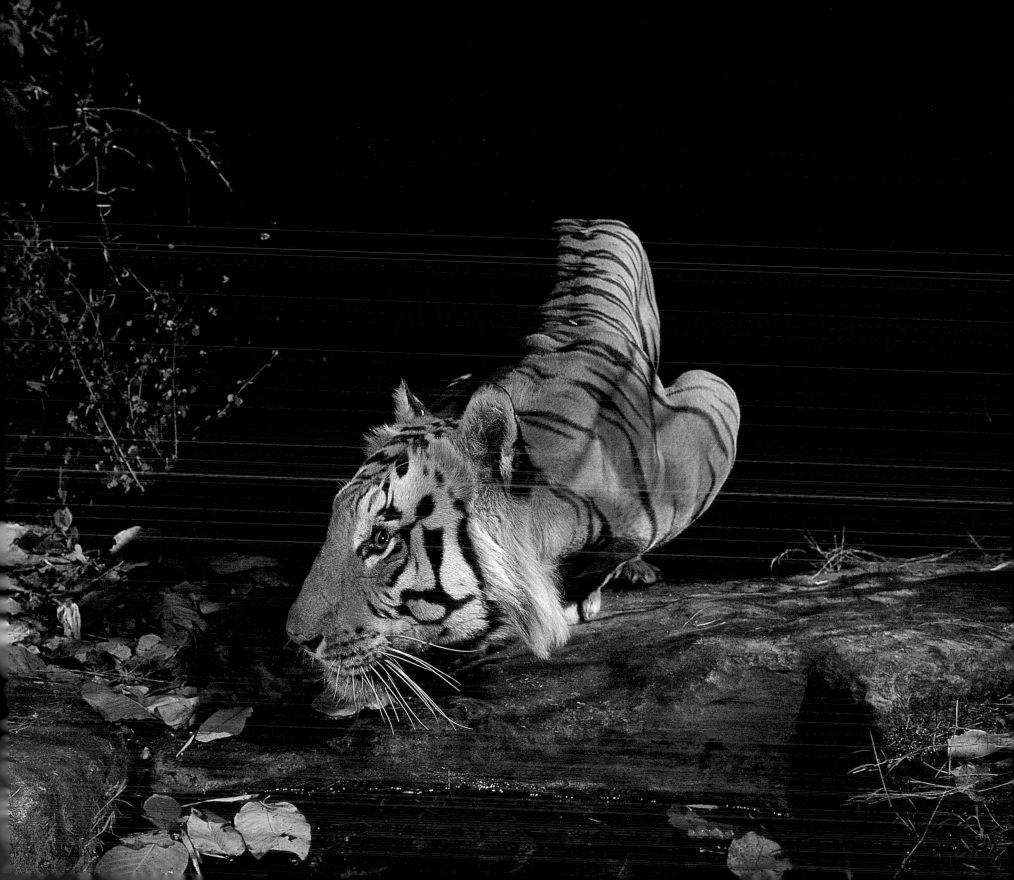

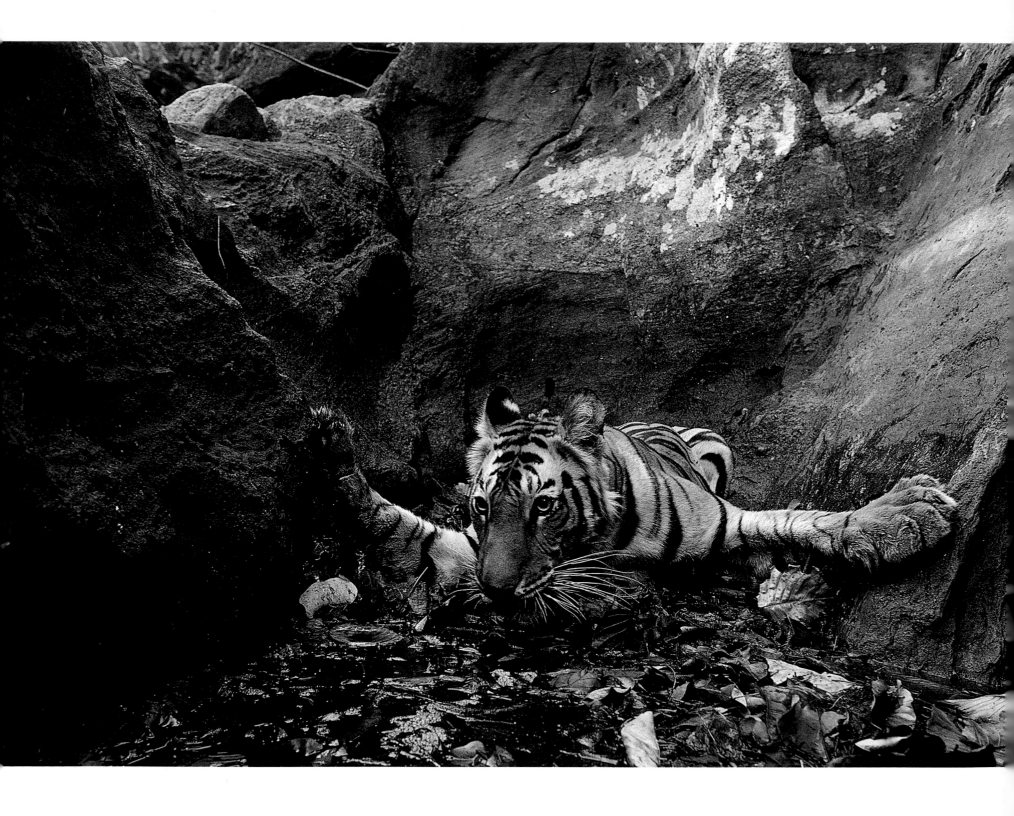

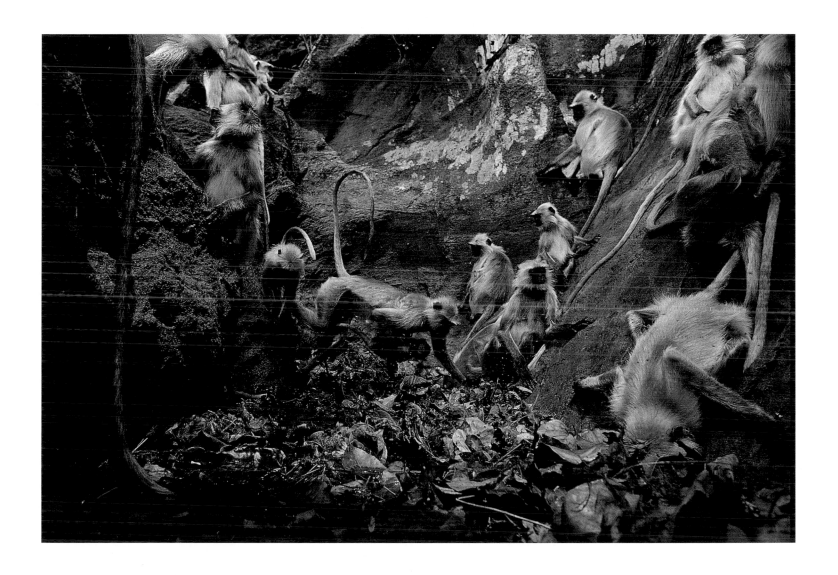

Bachhi, or "Little Girl," one of Sita's daughters from her fourth litter (opposite), and a thirsty band of
gray langurs visit the same shallow fetid pool, filled with leaves and monkey urine.

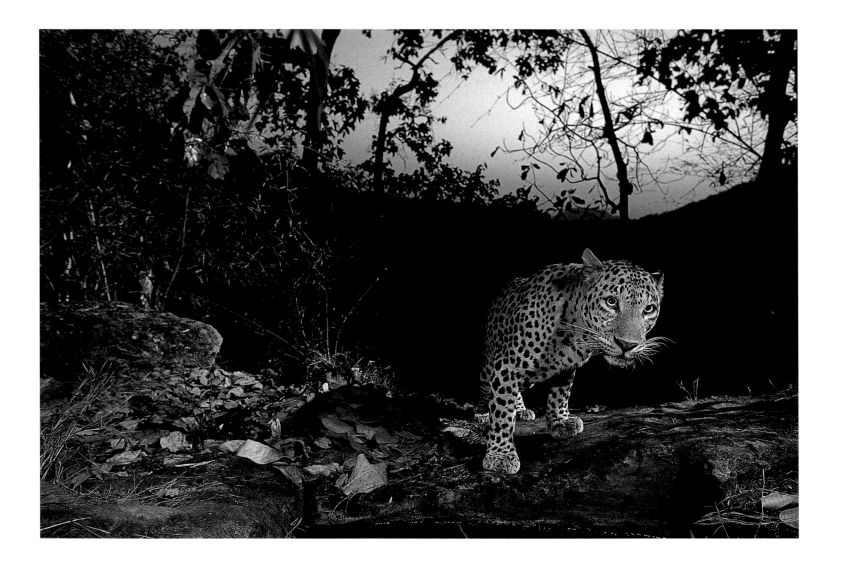

Within hours of one another, a leopard and still more langurs slake their thirst at the identical spot.

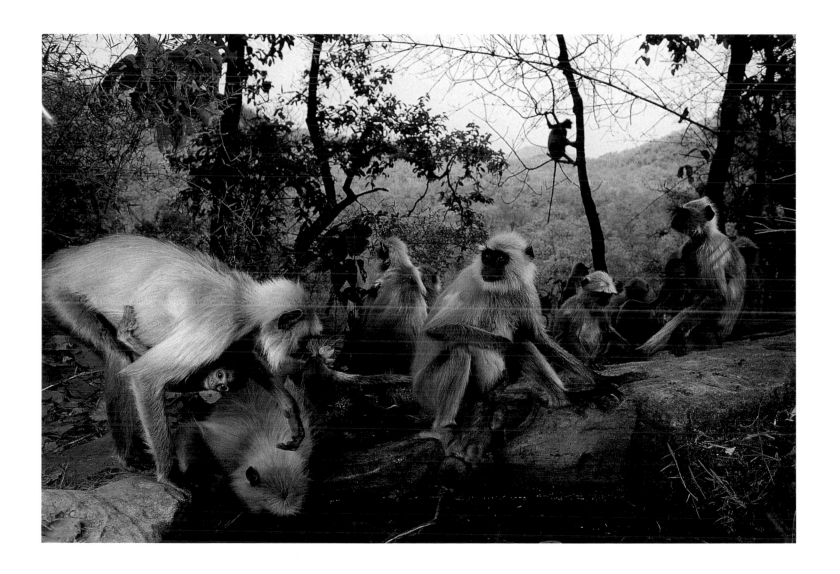

Comings and goings: Egyptian vultures

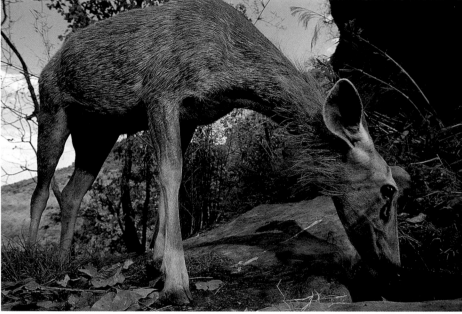

Sambar doe

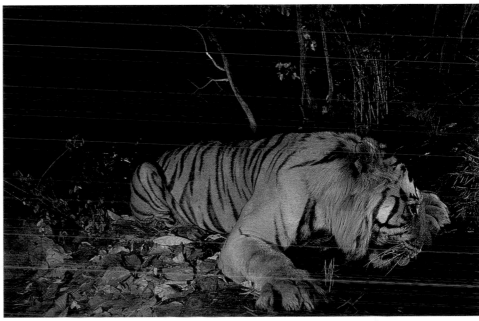

Sloth bear Charger, the dominant male

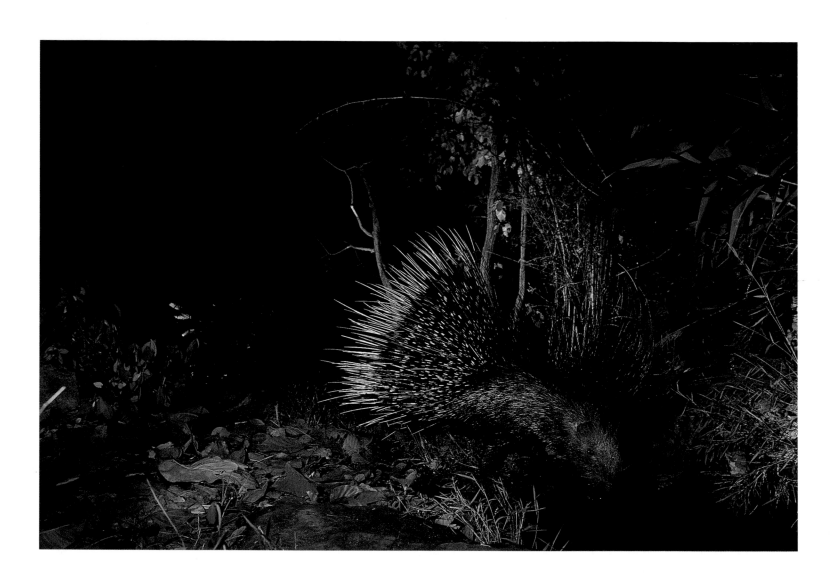

Backlash: The clumsy efforts of the transient young tiger (opposite) to kill an Indian porcupine
like this one resulted in a face full of quills and a potentially fatal infected wound to its left front paw.

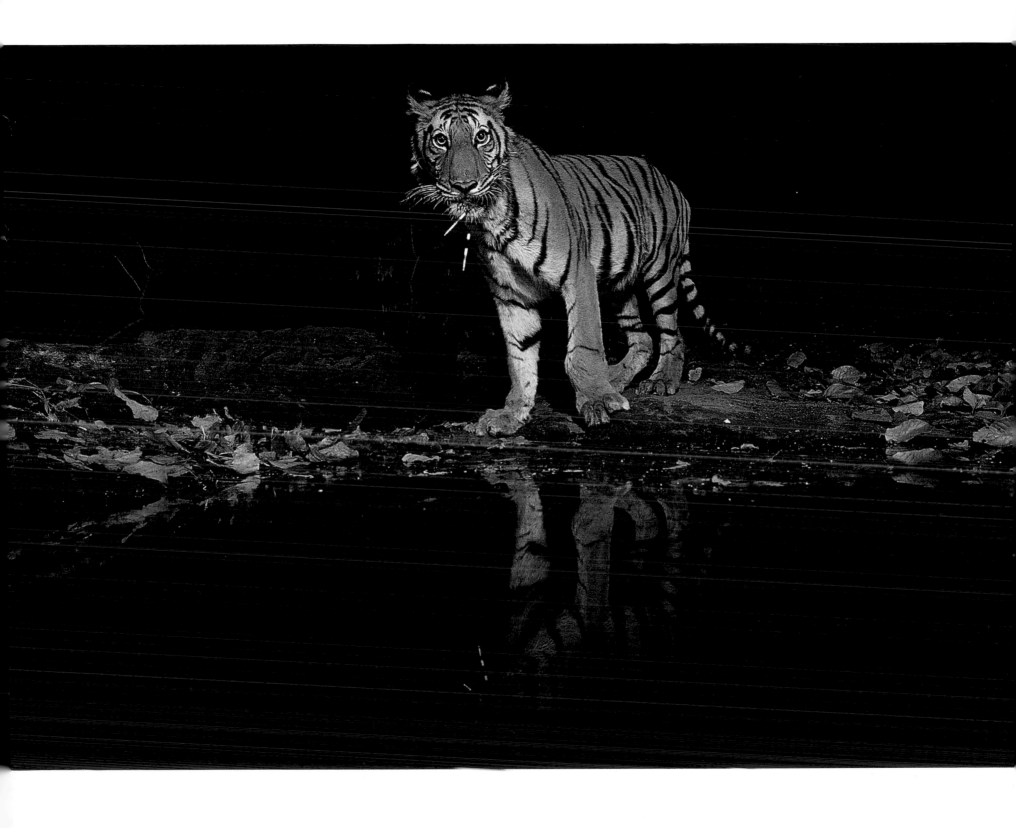

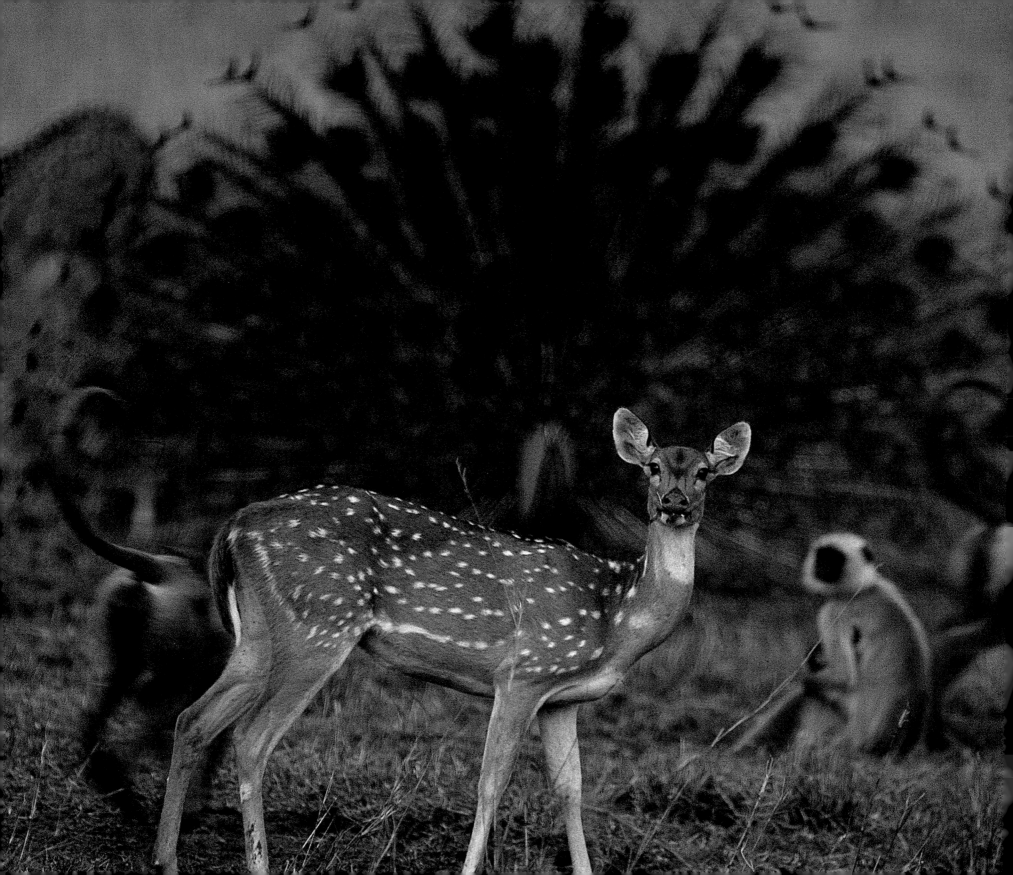

Tigers are opportunists: Given the right circumstances, they will kill and eat nearly anything that crosses their path—including the chital deer, peacock, and langur monkeys huddled together for safety on the opposite page. But efficiency and the need to conserve their own energy dictate that they focus their hunting skills on the largest obtainable fare. Depending upon the kind of ecosystem in which they live, tigers routinely make massive meals of elk, buffalo, and gaur, and sometimes even devour the progeny of the rhinoceros and elephant.

Whatever the size of their potential prey, cubs have to be carefully taught to stalk and kill on their own. Training them to do that is a laborious 16- to-22-month trial-and-error process, during which tigresses like Sita must provide for themselves as well as for their voracious offspring.

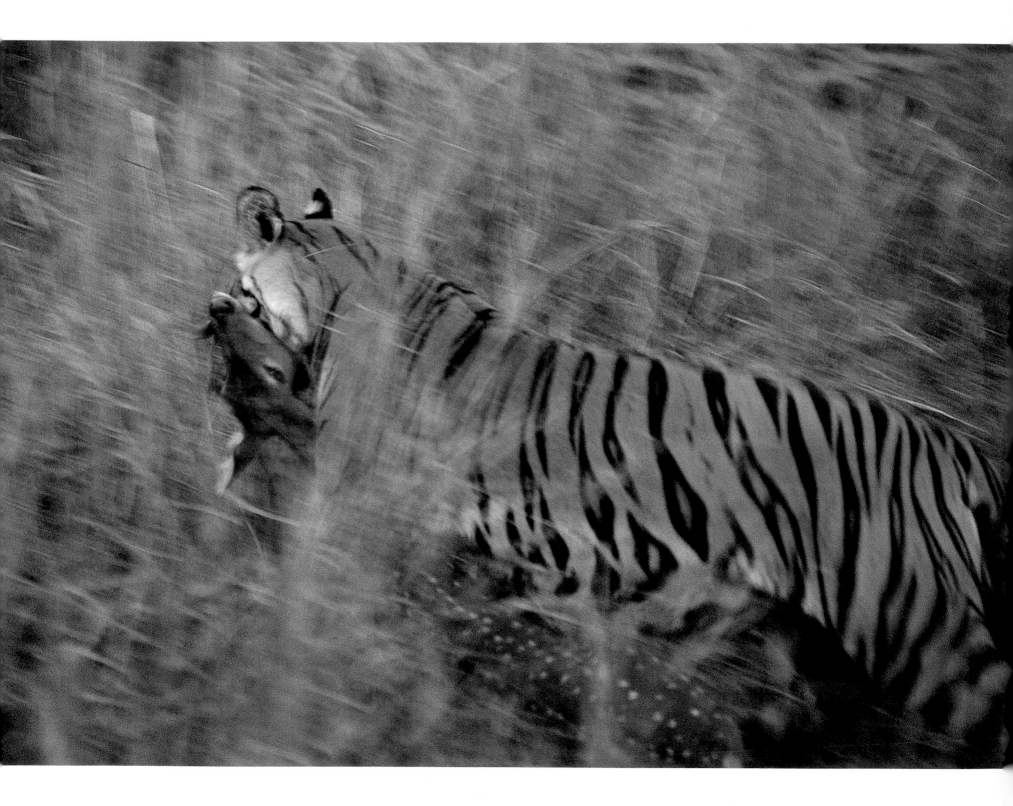

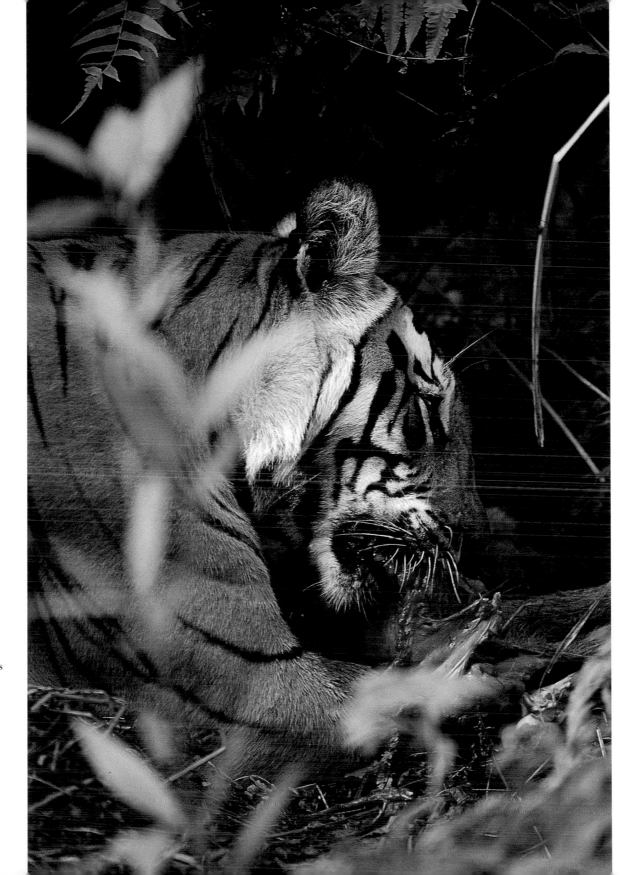

At dusk, Sita carries a freshly killed chital. By morning she was back hunting again, in search of more meat with which to feed herself and her hungry cubs.

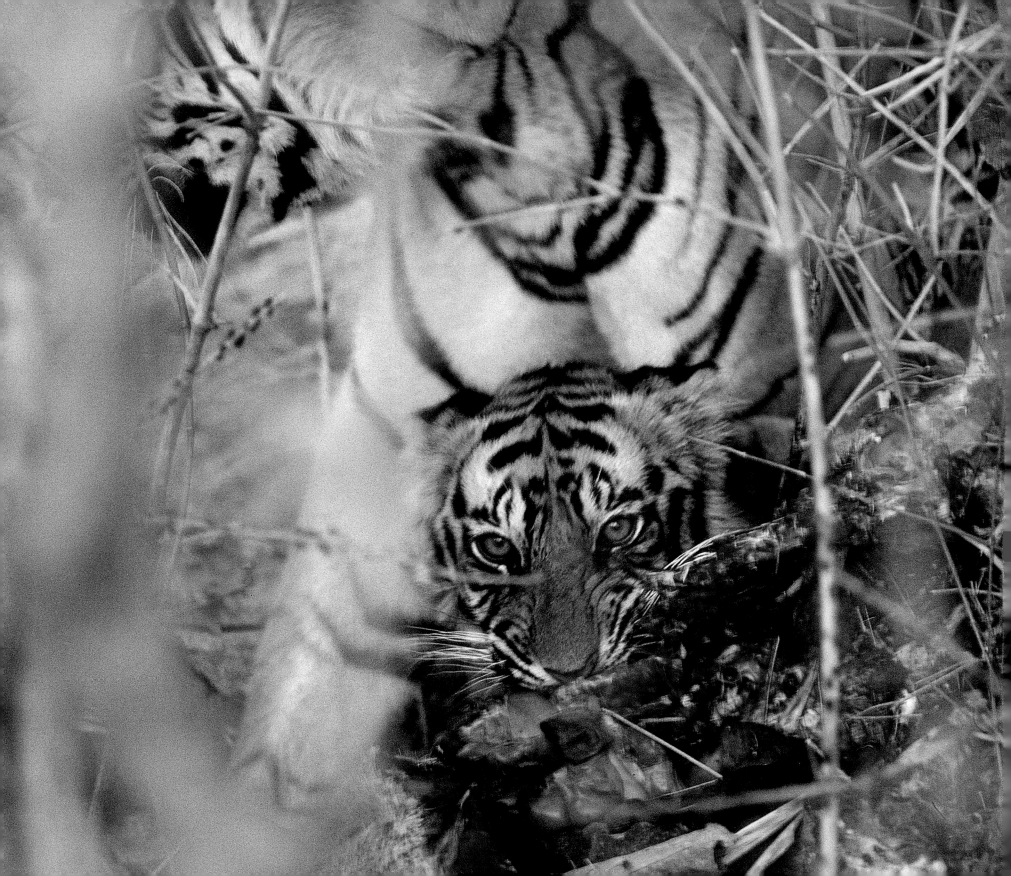

Sheltered by her mother, one of Sita's cubs learns to savor sambar meat. Larger than a chital, the sambar provided the family with food for three days.

Sita's grown daughter, Bachhi, snarls
at the presence of a photographer
concealed in a hide. She has carved
out a territory adjacent to her
mother's and there manages to
feed three cubs of her own.

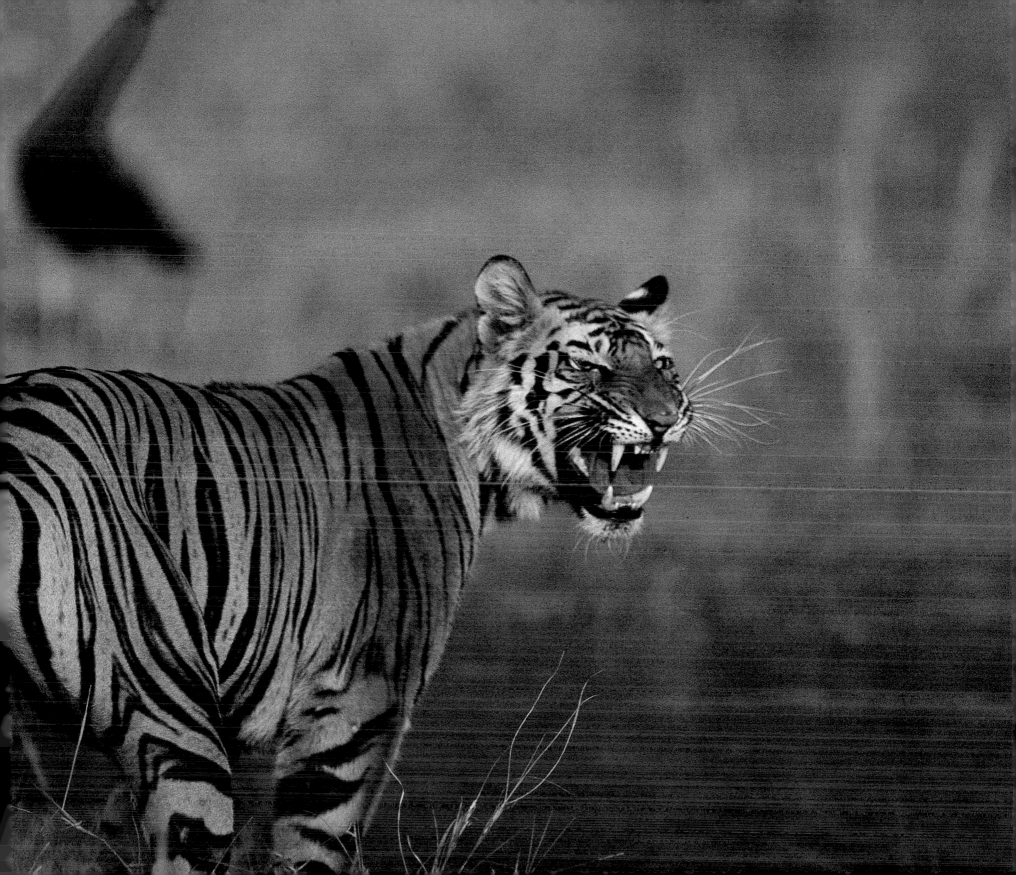

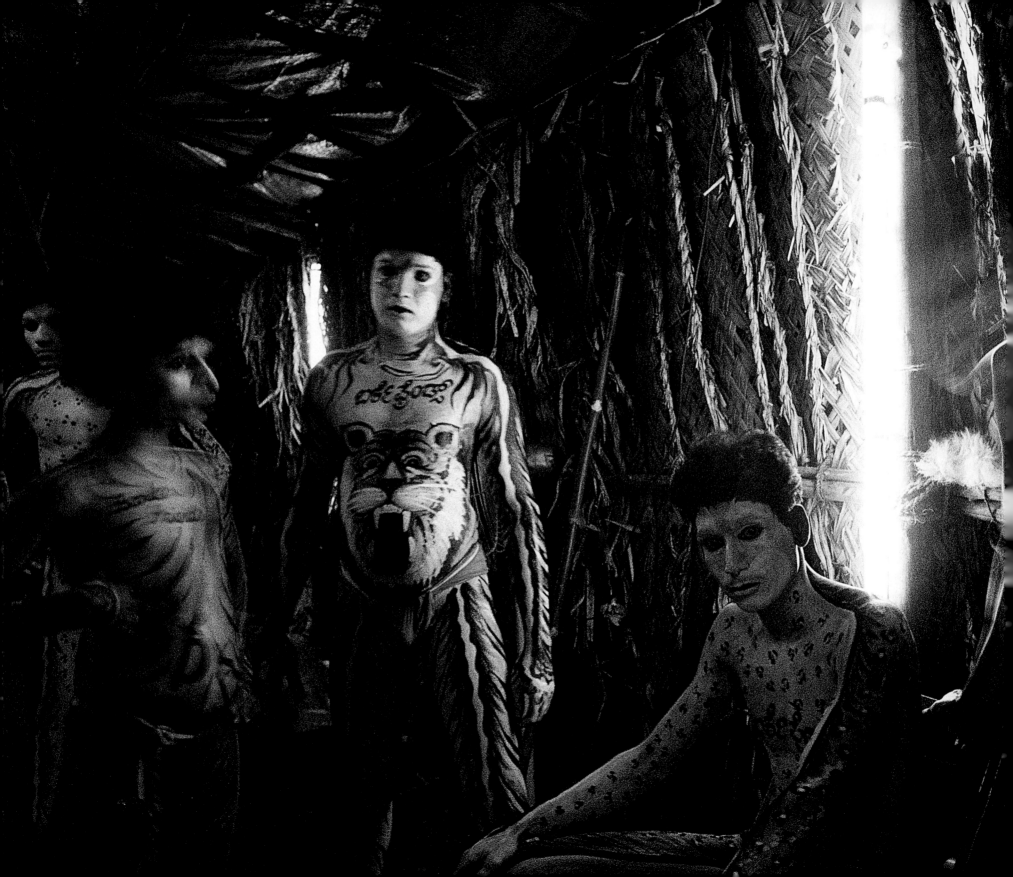

The tigerish patterns that cover the bodies of the Indian dancers on the opposite page may have become Disneyfied in recent years, but the devotees' reverence for the great predator has not altered over the centuries: In Hindu mythology, the goddess Durga is often depicted riding a tiger.

Wherever tigers roamed, they have been traditionally revered. In India, they are seen as symbols of royalty as well as divine power. In China, they represent yang, or good, in the timeless struggle against the dragon of yin, or evil. In parts of Thailand, Malaysia, and Sumatra, tigers have traditionally been symbols of divine retribution. But in Asia, as elsewhere, human beings also seem strangely driven to find ways to demonstrate their supposed superiority to this greatest of the great cats.

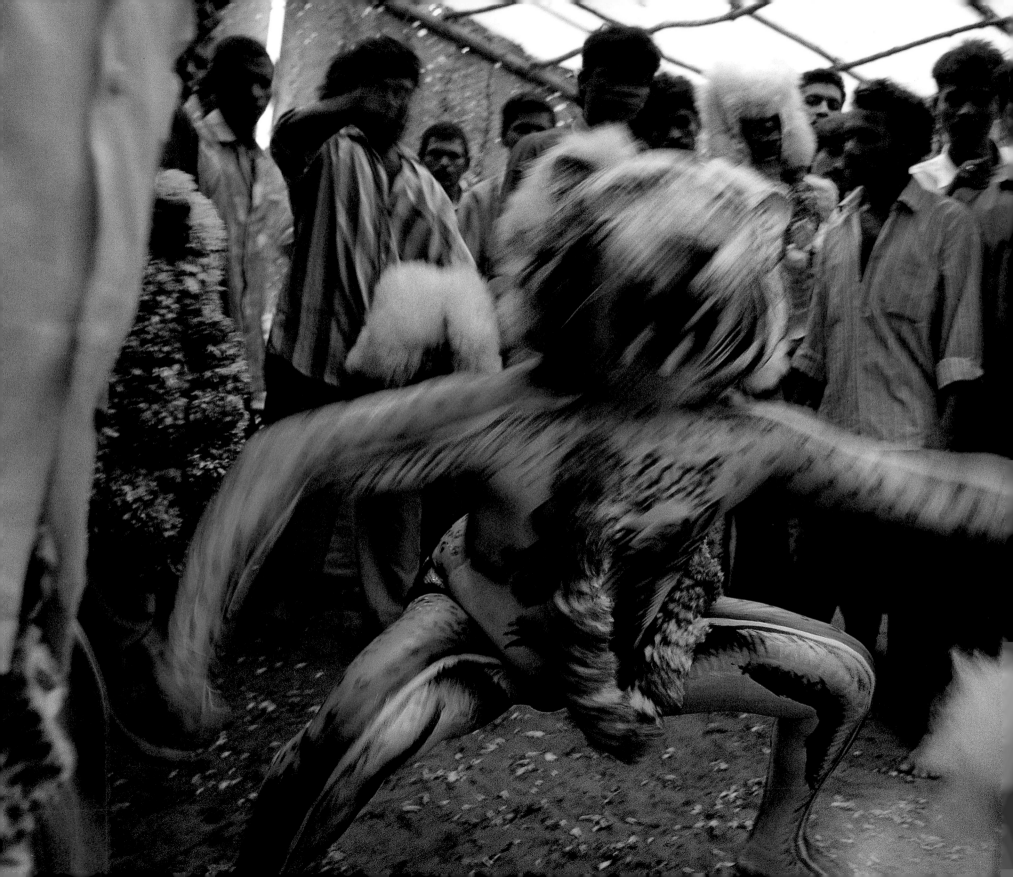

In Mangalore, tiger-striped dancers
whirl and stamp during a procession
to Durga's temple.

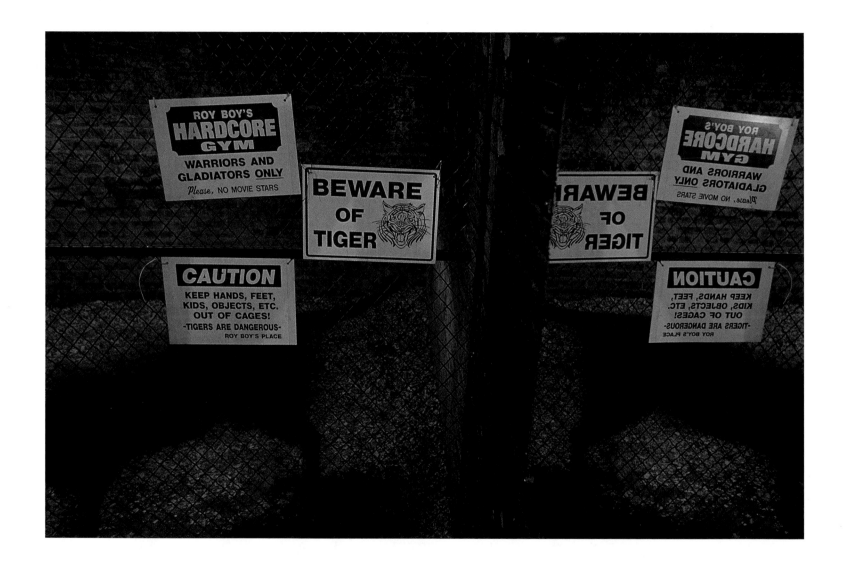

To provide macho excitement for muscle builders working out nearby, two tigers are kept caged in the basement of Roy Boy's Tattoo Parlor and Hard Core Gym in Gary, Indiana.

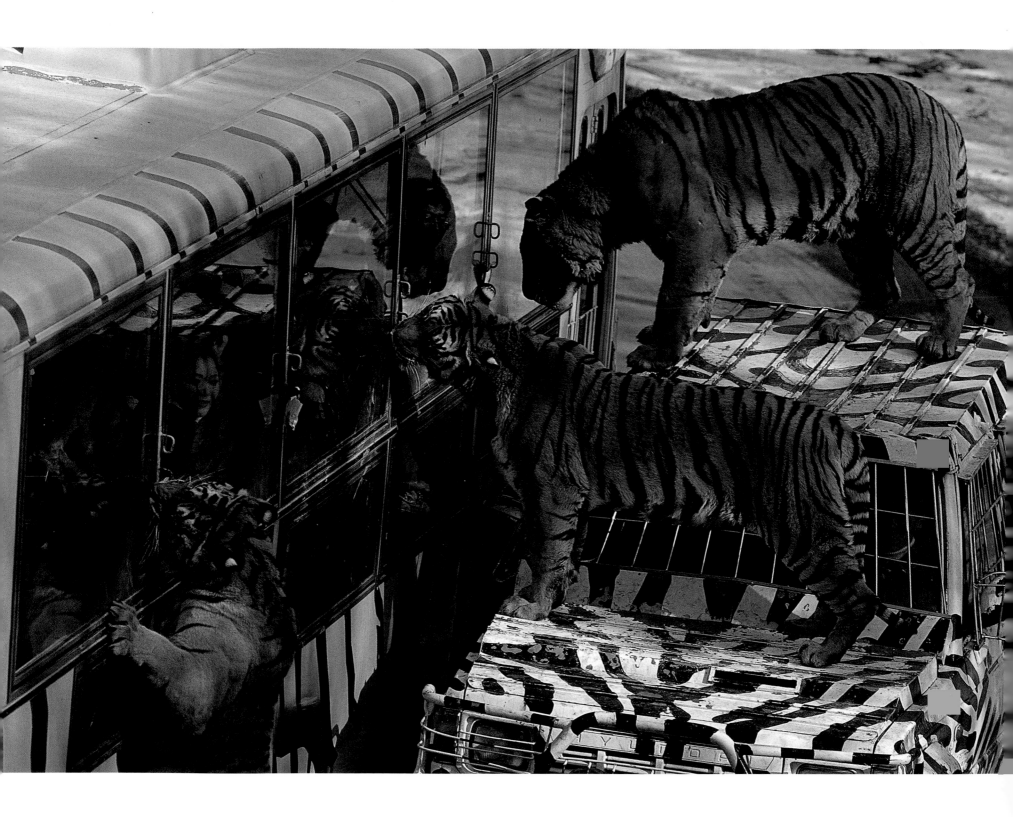

From the safety of a specially modified bus, visitors to the Everland Zoological Gardens near Seoul,
South Korea, can have a risk-free, close-up look at captive tigers tearing at suspended chunks of meat.

If they have enough money—and enough courage—visitors to the Sriracha Tiger Zoo near Bangkok, Thailand, can bottle-feed a tiger cub. The Zoo is said to be home to nearly 130 tigers that are fed on the by-products of thousands of pigs, chickens, and crocodiles raised commercially nearby. It is unclear why so many tigers are being bred here—only about 30, mostly very young, animals are ever on exhibit—and some suspect that they are meant for slaughter and sale to manufacturers of Chinese traditional medicines, if the international ban on that trade is ever lifted.

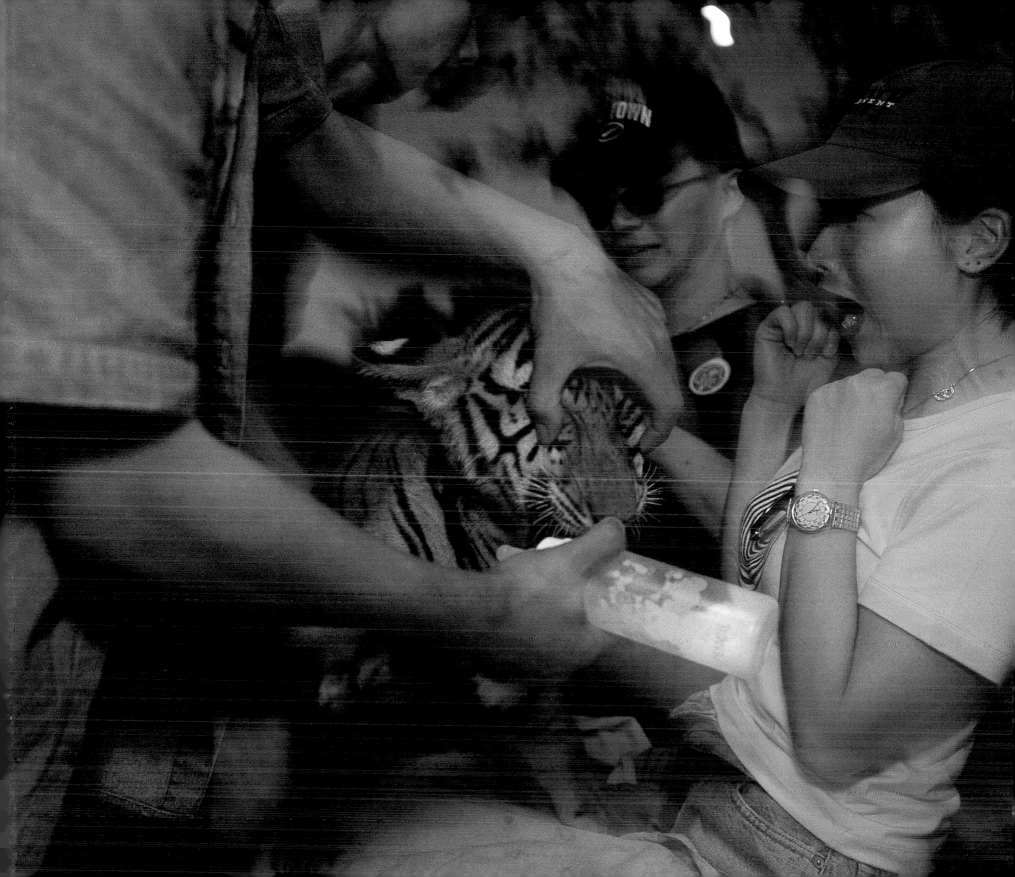

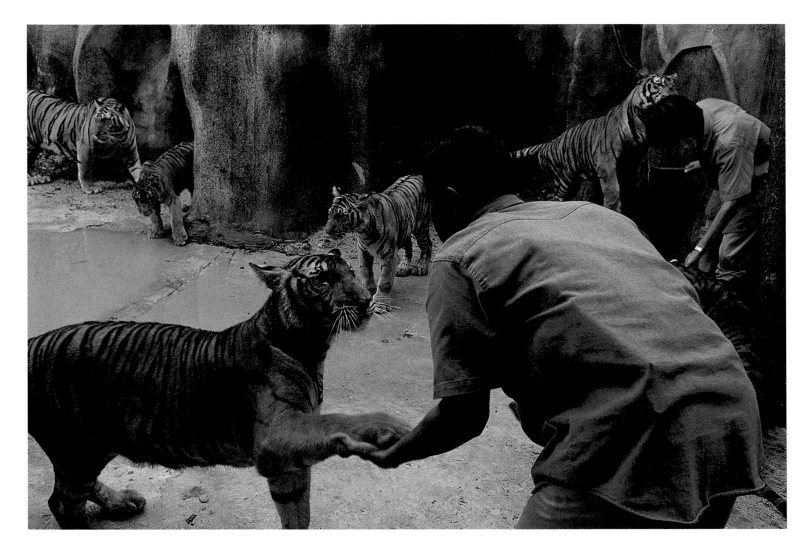

At the Sriracha Tiger Zoo, visitors can watch keepers play with adolescent tigers whose claws have been removed, or they can gape at this desperately anxious tigress (opposite) nursing her two-week-old cubs behind plate glass. She is more fortunate than many other tigresses at the zoo: Some cubs are taken away while still nursing so that their mothers can be made to produce as many as three litters a year.

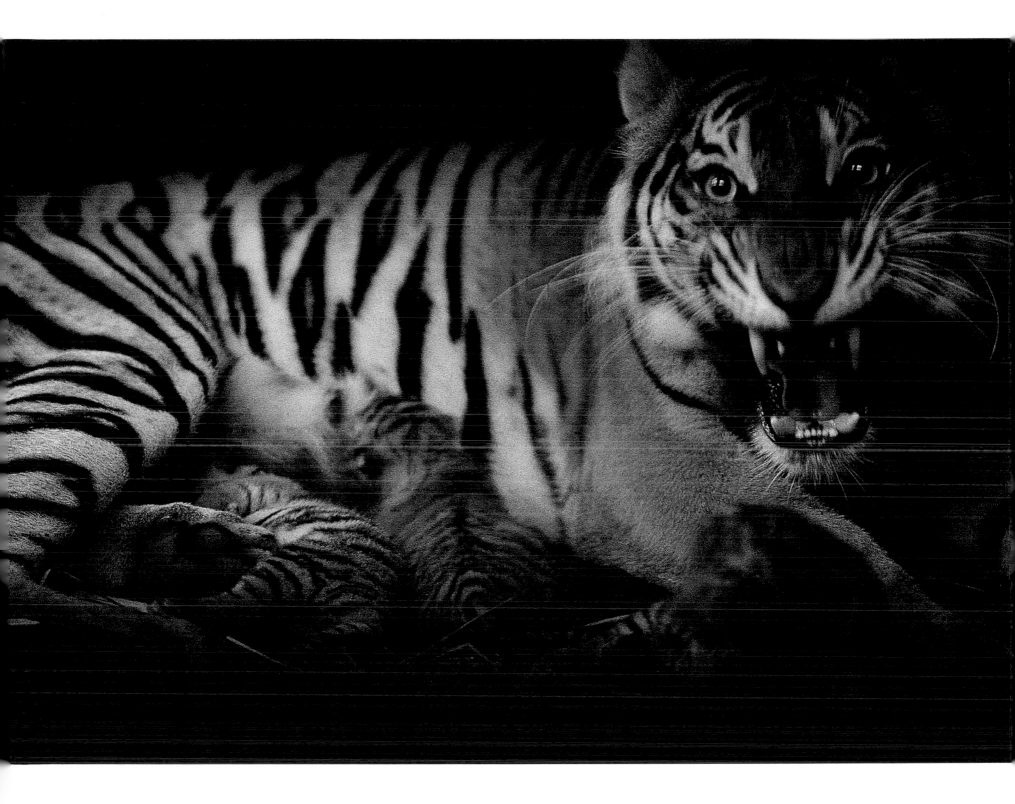

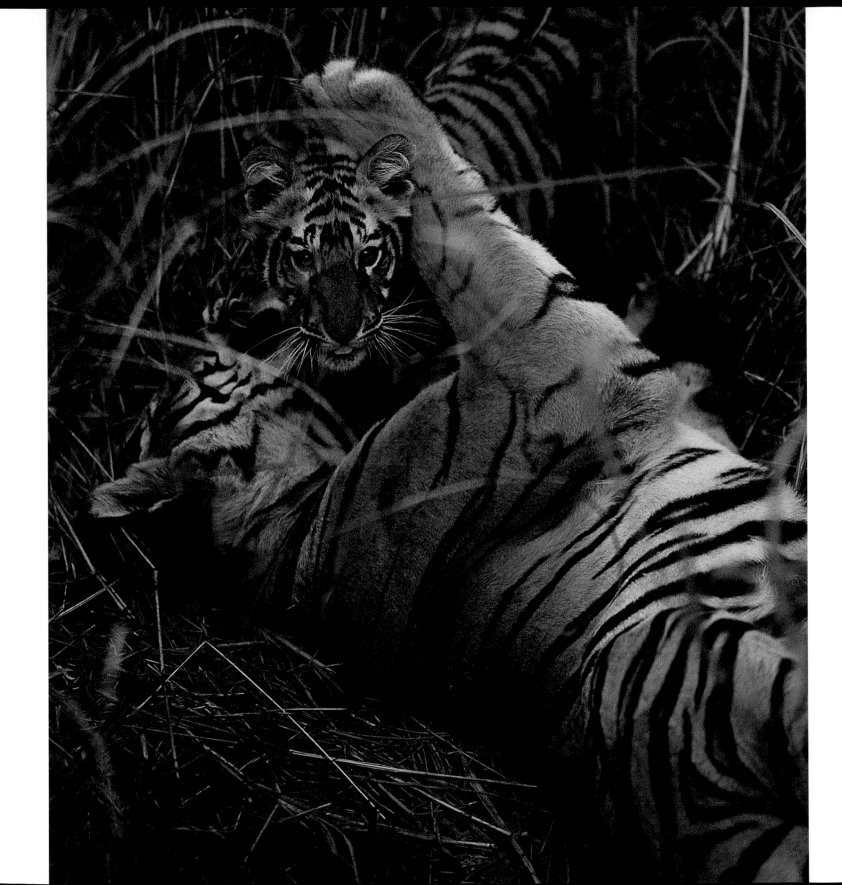

What wild tigers need most—whether they live in the dry deciduous forests of central India or the snow-filled woods of Siberia or in any of the other fast-disappearing wild places in-between—is simply to be left alone. Despite the heavy demands made upon tigresses like Sita, whose cubs' survival depends on her ability to shield, nurture, and school them for the first 20 to 24 months of life, tigers flourish on their own, provided they have enough prey, enough water, and enough room.

But in a world in which human populations continue to soar, space is at a premium, and the appeal of quick profits often proves irresistible. Finding ways to provide tigers like Sita and her cubs with the protection and solitude they need remains the greatest challenge facing those who wish to keep the tiger free.

Sita and one of her seven-month-old
cubs stalk past the entrance of an
ancient man-made cave that she uses
to avoid the worst of the summer heat.

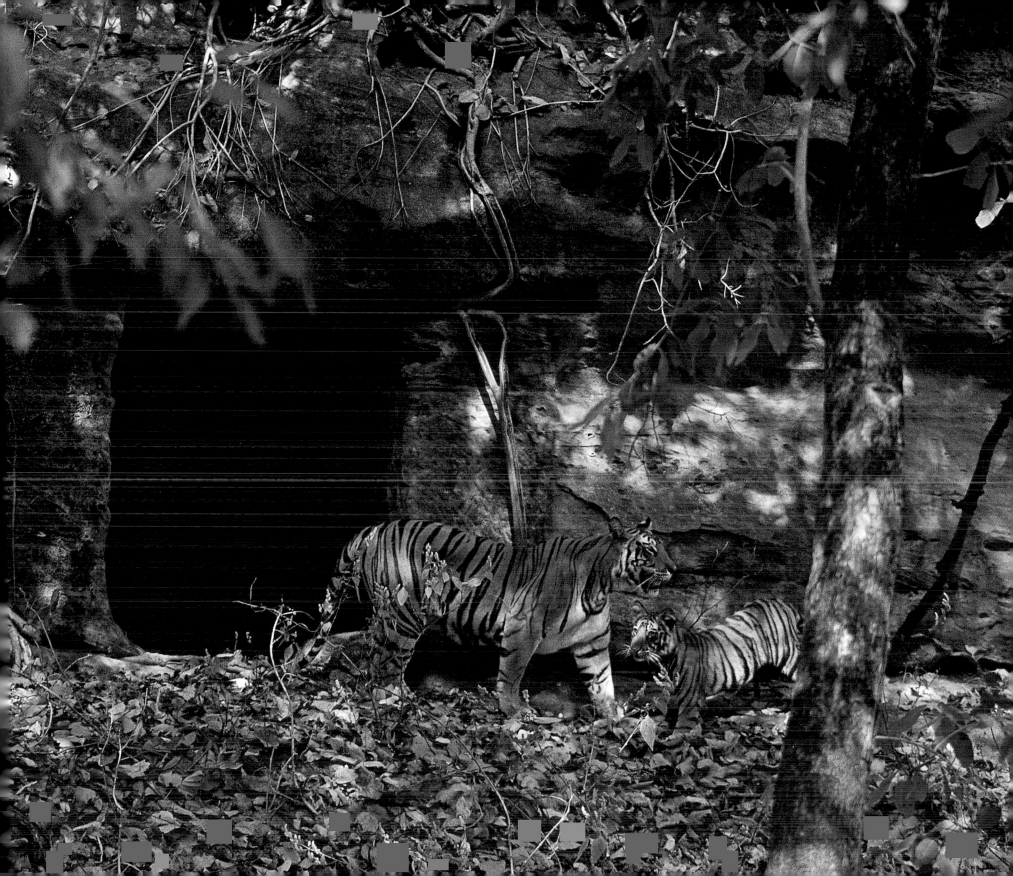

One of Sita's cubs crouches
impatiently in thick grass, waiting
until its mother signals that it is safe
to return to the sambar she had
killed and hidden the night before.

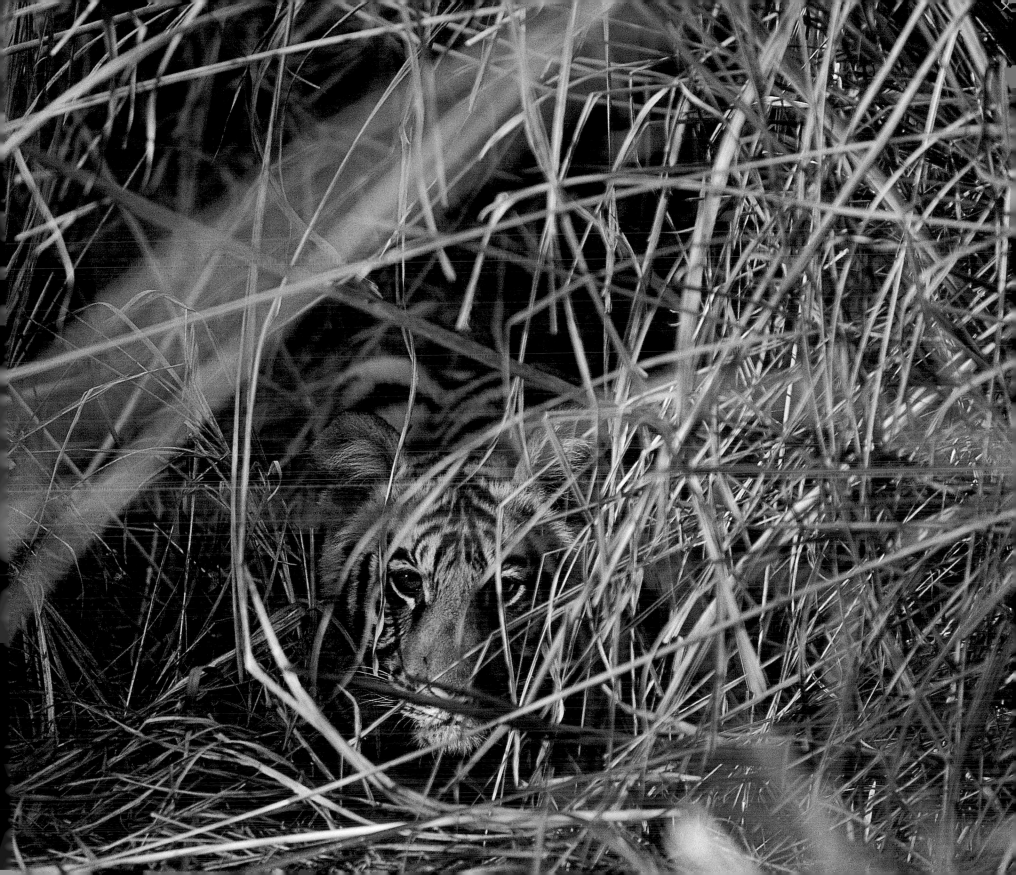

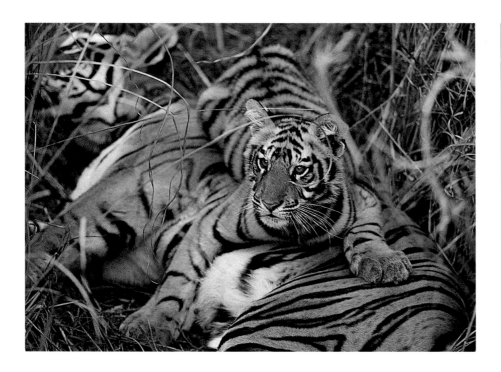 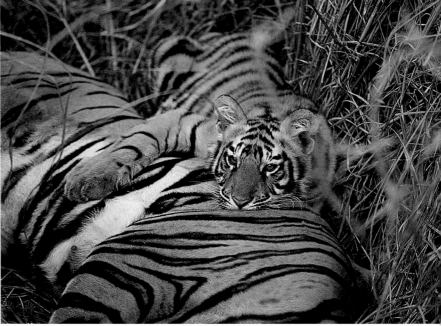

Nothing this impatient cub can think to do seems to disturb its weary mother's sleep.

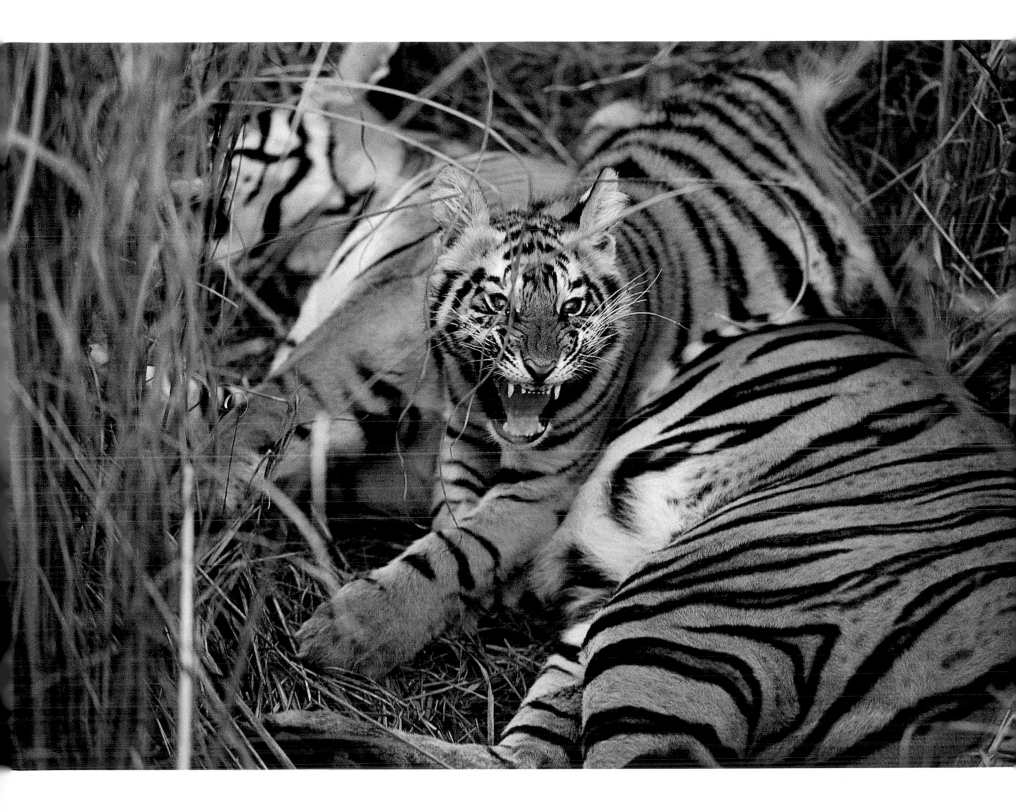

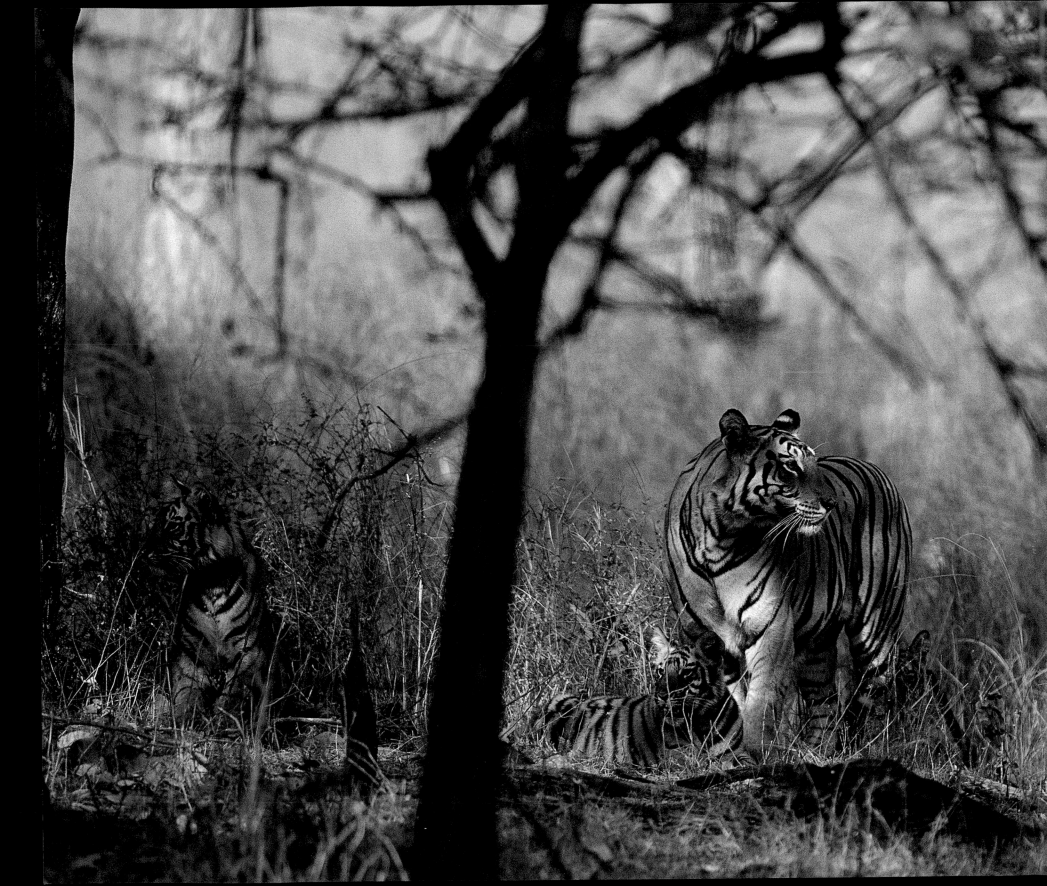

Sita carefully surveys the jungle
before calling for her cubs to leave
the security of the thicket in which
she has concealed them.

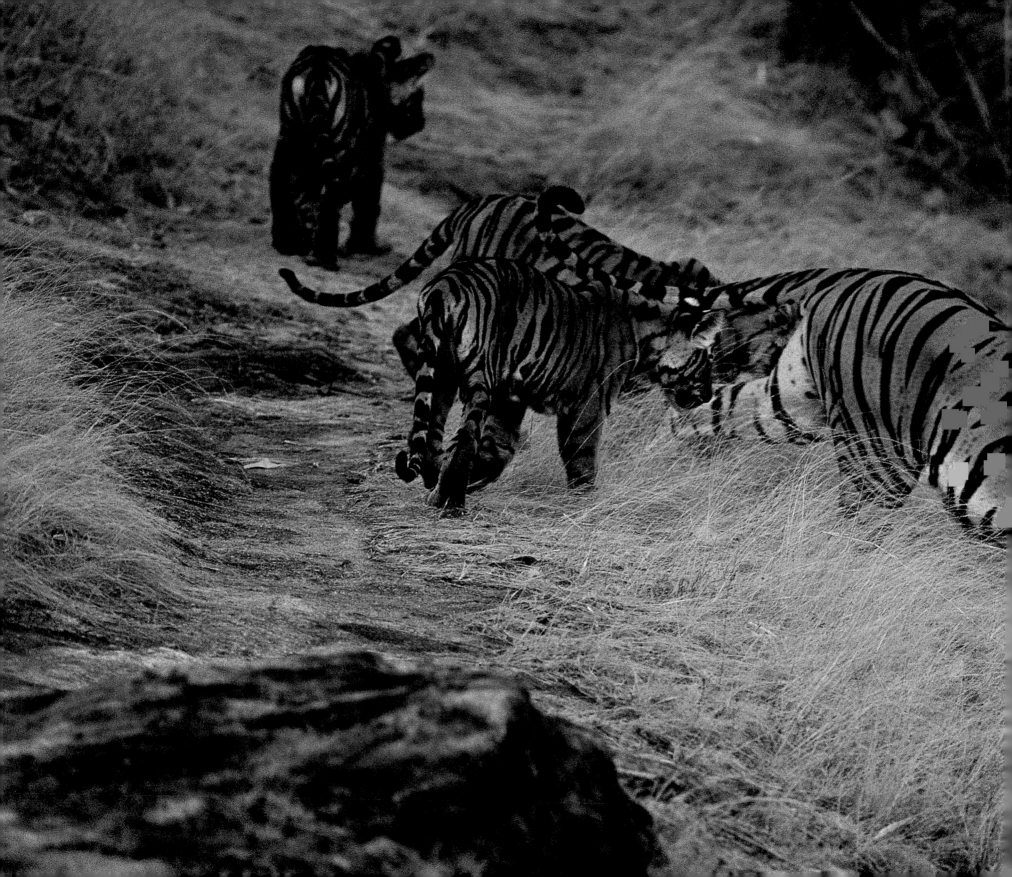

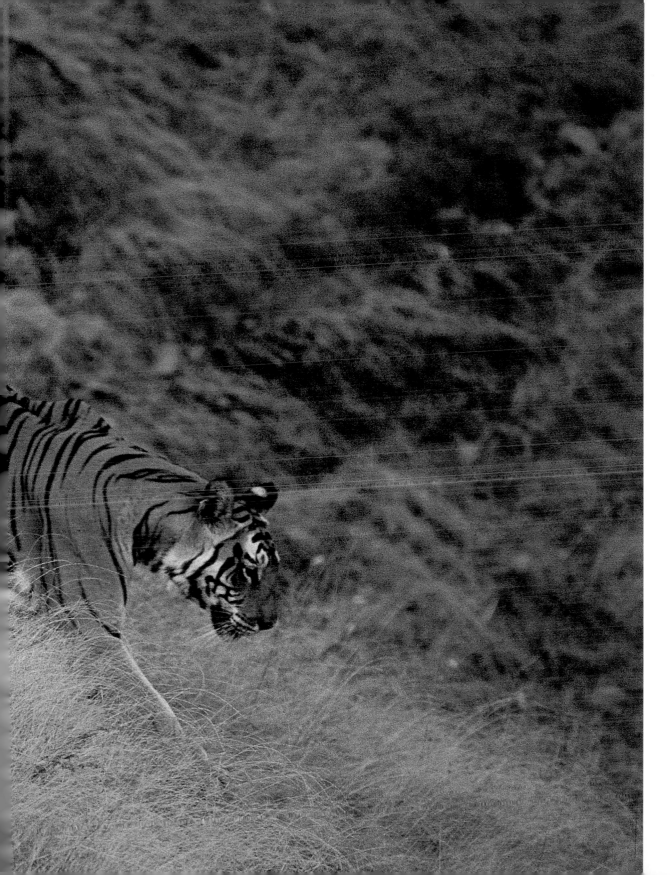

Sita leads the way back to her kill.
Her cubs still have much to learn
from their mother before—at 18 to 24
months—they leave her and go out
into the world where they will have to
compete for territories of their own.

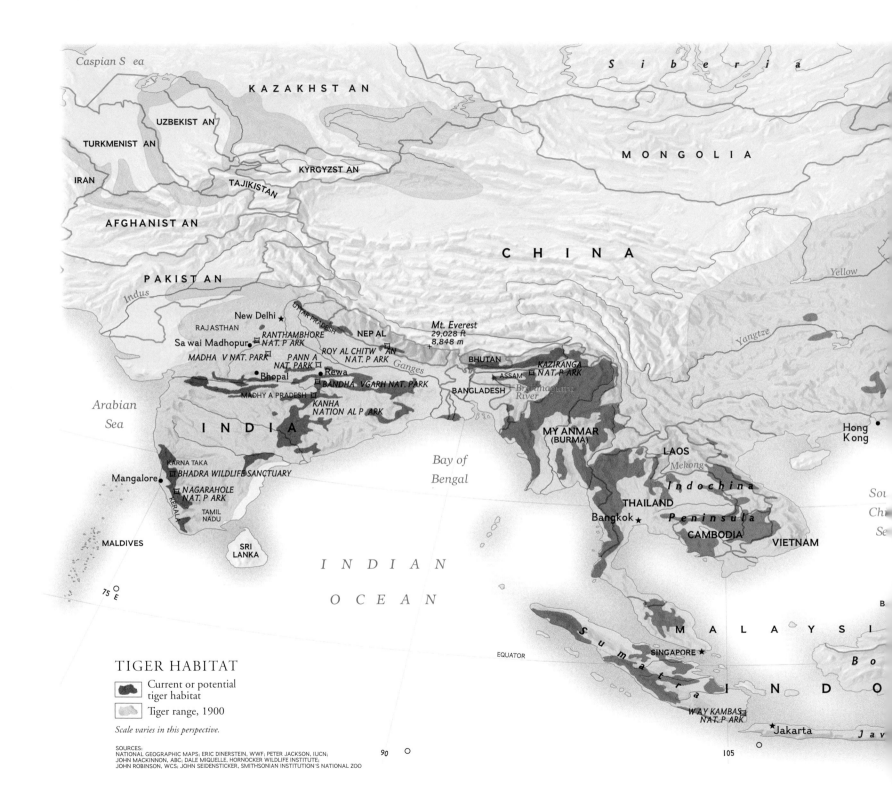

Caspian Sea

Siberia

KAZAKHSTAN

UZBEKISTAN

MONGOLIA

TURKMENISTAN

KYRGYZSTAN

IRAN

TAJIKISTAN

AFGHANISTAN

CHINA

PAKISTAN

Yellow

Indus

New Delhi ★

UTTAR PRADESH

Mt. Everest
29,028 ft
8,848 m

Yangtze

RAJASTHAN

NEPAL

RANTHAMBHORE
NAT. PARK

Sawai Madhopur ⊡

ROYAL CHITWAN
NAT. PARK ⊡

BHUTAN

KAZIRANGA
NAT. PARK ⊡

MADHAV NAT. PARK

PANNA
NAT. PARK ⊡

ASSAM

Hong
Kong ●

Ganges

Bhopal ●

● Rewa

BANGLADESH

Brahmaputra
River

Arabian
Sea

MADHYA PRADESH ⊡

BANDHAVGARH NAT. PARK

KANHA
NATIONAL PARK

INDIA

MYANMAR
(BURMA)

LAOS

Mekong

KARNATAKA

BHADRA WILDLIFE SANCTUARY ⊡

Bay of
Bengal

Indochina

Mangalore ●

NAGARAHOLE
NAT. PARK ⊡

THAILAND

Peninsula

Sou
Chi
Se

KERALA

TAMIL
NADU

Bangkok ★

CAMBODIA

VIETNAM

MALDIVES

SRI
LANKA

INDIAN

OCEAN

75
E ○

MALAYSI

Su
ma
tra

SINGAPORE ★

B

EQUATOR

INDO

Bo

WAY KAMBAS
NAT. PARK ⊡

★ Jakarta

Jav

TIGER HABITAT

Current or potential
tiger habitat

Tiger range, 1900

Scale varies in this perspective.

90 ○

105

SOURCES:
NATIONAL GEOGRAPHIC MAPS; ERIC DINERSTEIN, WWF; PETER JACKSON, IUCN;
JOHN MACKINNON, ABC; DALE MIQUELLE, HORNOCKER WILDLIFE INSTITUTE;
JOHN ROBINSON, WCS; JOHN SEIDENSTICKER, SMITHSONIAN INSTITUTION'S NATIONAL ZOO

RUSSIA

Amur

Manchuria

SIKHOTE-ALIN
BIOSPHERE RESERVE

45

NORTH
KOREA

Sea of
Japan

Seoul
SOUTH
KOREA

JAPAN

30

East
China
Sea

TROPIC OF CANCER

Taiwan

15 N

PHILIPPINES

N E S I A

120

Bali

CONSERVATIONISTS

Environmental Investigation Agency
Apartment 324
1701 16th Street, N.W.
Washington, D.C. 20009

Hornocker Wildlife Research Institute
P.O. Box 3246
University Station
Moscow, Idaho 83843-0246

Save the Tiger Fund
National Fish and Wildlife Foundation
1120 Connecticut Avenue, N.W.
Suite 900
Washington, D.C. 20036

World Wildlfe Fund USA
1250 24th Street, N.W.
Washington, D.C. 20037-1175

Wildlife Conservation Society
The Bronx Zoo
185th Street and Southern Boulevard
Bronx, New York 10460

Wildlife Protection Society of India
Thapar House
134 Janpath
New Delhi, India 11001

Tiger Action Fund for India
290 West End Avenue
Suite 17-C
New York, New York 10023

No one knows how many wild tigers survive in the world. The most common estimate of 5,000 to 7,000 is little more than a guess, based on incomplete and sometimes misleading data. But researchers working for the World Wildlife Fund and the Wildlife Conservation Society have recently combined satellite imagery with the best available estimates from ground-level research to create a map that identifies those forests in which they believe tigers have at least some chance of survival. Their hope is that the governments of the 14 tiger-range countries can be persuaded to set aside the most promising of these areas in perpetuity to save the species.

149

ACKNOWLEDGMENTS

MICHAEL NICHOLS

The title of this book is inspired not by the Chinese calendar but is meant to be a tribute to two classic works by George Schaller—*The Year of the Gorilla* and *The Deer and the Tiger.* I owe NATIONAL GEOGRAPHIC and illustrations editor John Echave a great debt for keeping me on track and sticking with me even though the photographs came so slowly that the investment of time and money must sometimes have seemed a poor one.

The existence of this book is the result of the perseverance of Leah Bendavid-Val, a true champion of photography. Kate Glassner Brainerd, my frequent design partner, brought clarity and elegance to the marriage of photographs with Geoff Ward's words.

When I first went to India, I knew nothing about how or where to photograph. I was armed only with a list of contacts from Geoff and Diane Ward. This led me to Toby Sinclair who graciously shared his vast knowledge of the subcontinent's wildlife and set me on a path to Bandhavgarh National Park.

There I met Nanda S.J.B. Rana, a member of Nepal's former ruling family. Nanda is not a biologist—he is in fact a former hunter. But he is obsessed with the tigers of Bandhavgarh and knows their habits as well as a human can. He became my guide and friend and these photographs would not have been possible without his help.

My assistant and partner through this entire project, Roy Toft, deserves a medal for his courage in checking camera traps often guarded by a sleeping tiger.

Special permission and cooperation from the Forest Department of Madhya Pradesh made the methods used to make these photographs possible.

This work could not have happened without help and cooperation from many. I offer acknowledgment and thanks to the following: Salim Ahamad, Bob Anderson, Kate Anglin, Doug Armstrong, Chris Austria, Lisa Backus, Sergey Berevnuk, Narayan Singh Bhayal, Dharan Dar Boro, Ines Burger, Thea Chalmers, Stephen Galster, Kat Gidding, Andy Goldfarb, Joanna Van Grusen, Erin Harvey, Ginette Hemley, Sarah Hoff, Kenneth Houseman, Roosevelt Howard, Nell Hupman, Jubert Van Ingen, Bok Sakon Jaisomkom, Ullas Karanth, Tom Kennedy, Ushakiran Khandelwal, Kent Kobersteen, Alexey Kostyrya, Sam La Budde, Butch Lama, Andrey Lebedev, Frank Lieberman, Tony Lynam, Jansen Manansang, Ragu Ram, Linda Matlow, Robert Mather, Corey Meacham, Dale Miquelle, P. K. Mishra, S. K. Nagar, Lalit M. Nath, Latika Nath, M. D. Parashar, Howard Quigley, George Phocus, Alan Rabinowitz, Nina Rao, Fateh Singh Rathore, Dr. Goverdhan Singh Rathore, Tim Redford, Alphonse Roy, S. Deb Roy, Krishna K. Roy, Siegfried & Roy, Roy Boy and his wife Debby, R. C. Sharma, John Seidensticker, Krishna Kumar Singh, Sergey Shaitaraov, Danilov Sheveiko, Sergey Sheveiko, Vladimir Ivanovich Shetinin, Brett Simison, Lee Simmons, Susan Smith, Agit Sonakia, Carol Starling, B. N. Talukdar, Valmik Thapar, Ron Tilson, Hashim Tyabji, A. B. Wade, Brian Weirum, Brian Werner, Ron Whitfield, Belinda Wright, S. K. Yadav, Kenji Yamaguichi, Betty Young, Victor Yudin, and Chad Zierenberg.

With special thanks to elephant mahouts Daya Ram, Phool Singh, Vishnu, and Kuttapaan.

Roy Toft made the photograph of a snarling Charger that appears on page 75. The collage on page 31 is the result of still-life master Terry Heffernan agreeing to help an old friend.

Above all, I thank Reba Peck, my partner, for the love, support, patience, and artist's eye that has made everything for me possible.

GEOFFREY C. WARD

've been writing about Indian tigers and Indian jungles off and on for nearly 15 years now, learning each year how little I really know about either subject. That is not the fault of my teachers, all of them dedicated to the survival of Asia's wildlife but somehow willing to find the time to help educate an eager amateur. Some are mentioned in the text of this book; others are not. But I am profoundly grateful to every one of them: Divyabhanusinh Chavda, Raghu Chundawat, Ullas Karanth, Fateh Singh Rathore, S. Deb Roy, Billy Arjan Singh, Valmik Thapar, and Hashim Tyabji, all in India; and in the United States, Dale Miquelle, Alan Rabinowitz, George Schaller, and John Seidensticker—who was also kind enough to read the galleys of this book before it went off to the printer.

There are other individuals who have been of immeasurable help over the course of my travels, and I would like to thank some of them, too: Sheila Lawton, Avani Patel, Dr. Goverdhan Singh Rathore and his wife Usha, Toby Sinclair, and Sajni Thukral. My friend Shadi Ram Sharma has made thousands of miles of travel over some of the world's most exacting roads a pleasure as well as an adventure, and I want to thank him.

I owe a special debt to Mira Balram Singh and to her late husband, Balram, the best of companions, whom I shall always miss.

I'm also grateful to Bob Poole, my editor at NATIONAL GEOGRAPHIC magazine, to Leah Bendavid-Val, who saw this book through, to Kate Glassner Brainerd who laid it out, and to my friend Nick Nichols whose evocative pictures are the most vivid possible testament to his passion for tigers and the natural world.

Finally, I would like to thank my wife, Diane, who makes all things—including writing about tigers—possible; who shares my love for the Indian forest; and who has been tireless in her efforts to collect funds with which to help save them in the wild as co-chair of the Tiger Action Fund for India.

NOTES ON THE PHOTOGRAPHS

MICHAEL NICHOLS

Wild tigers are hard to see and harder to photograph. Most published photographs of supposedly wild tigers really show captive ones. In recent years there has been a proliferation of game farms where the photographer can pay a fee and shoot the exotic animal of choice in "natural" settings. Photographs of the Siberian, South China, Indochinese, or Sumatran subspecies almost always involve some trickery—an outdoor enclosure where the tiger appears in the snow, a trained tiger taken to the snow where it is taken off the leash while photographs are made. There is even a notorious case of a wild rain forest tiger being captured and put into an enclosed area for a photo session. I find it very misleading to present nature in this manner. It blurs the meaning of wildness. We demean nature in so many ways. Must we tame it, too?

Bengal tigers can be photographed in the wild in India. The reasons are not complex. The relatively open vegetation in some parks allows tigers to be seen at a distance, and tourism at these parks has led to a few tigers becoming habituated to elephants and jeeps. As far as I know there is no wild tiger that will knowingly allow a human to approach on foot.

Still, photographing tigers took all the patience and stamina that I could muster. It also required a mass of time and commitment from my patron, NATIONAL GEOGRAPHIC. The photographs in this book were made over two years from November 1995 through December 1997 when I made the last of five trips to India and Bandhavgarh National Park. I shot 1,800 rolls of film. Don't be impressed or dismayed by that figure: Most of those frames were filled by monkeys and deer, not elusive tigers. My editor, John Echave—in a moment of exasperation and, I hope, humor—sent me a fax that read simply: "Nick, please do not photograph any more monkeys or deer unless they are in a tiger's mouth."

I used three methods to make these pictures: Riding elephants, sitting in hides, and placing camera traps at water holes.

I was up most mornings at 4 a.m. and into the tigers' territory on elephant-back by dawn when its nightly prowl was winding down. We used pugmarks and the alarm calls of deer and monkeys to locate our quarry, but our average of success was about one tiger every five days. Most of the time the tiger was sleeping by the time I was able to photograph. I dropped cameras several times from the back of the elephant. Once we got too close to an injured tiger—Charger, the dominant male—in the tall grass and without warning he roared, jumped, and clawed the back of the elephant next to my feet. Neither the elephant, his mahout, nor I ever did that again. An elephant is not a tripod. It breathes, shifts its feet a lot, and would eat every leafy thing in sight if allowed. I had to use very fast lenses and shutter speeds in order to get sharp photographs. (Conversely, since I particularly like the dramatic blurs produced on film by moments of movement, the elephant sometimes worked in my favor.)

We built a hide made of tall grass attached to a bamboo frame near an important water hole, where I hoped to photograph a tiger as it came to drink. A tiger will not go through a barrier if it is unsure what is on the other side; a long strip of white cloth strung between elephants was all that was needed to drive tigers into the sights of hunters' guns in the old days. Hence the safety in the grass hide on the ground. I love these rules of nature and ordinarily felt safe inside the flimsy hide where I sat for 16 days. In all that time, I saw tigers for less than five minutes (the pictures on pages 16-17 and 106-107) and most of that was after dark. As the light faded one evening, the forest was literally reverberating with alarm calls. I could see nothing, until Charger suddenly appeared just outside the hide,

turned, and sprayed the door with urine. Even though I knew a tiger would not go through a barrier, I was huddled in the fetal position by then in the farthest corner of the blind. No pictures. Another night I shot a whole roll of a tiger that proved on daylight inspection to be a tree.

For me, the most satisfying method of taking pictures of tigers turned out to be what is now called camera-trap photography. I had previously worked for months in the Congo with this technique only to wind up with a single frame showing half a leopard's face. Technical problems. The central Indian jungle turns out to be the ideal environment to perfect this method. In summer the forest is dry and hot and water holes become magnets where camera traps could be placed and thirsty creatures would cautiously photograph themselves. Did the flash scare them? Our video evidence suggests that some animals did run away—especially sloth bears. But I assure you the animals in this predator-filled forest have much more to fear than these flashes. Charger never even blinked when the cameras went off and filled entire rolls of film while lounging in the water.

I loved photographing wild creatures this way. It seemed more on their terms than mine. The idea was to make the camera think the way I do without my being there. The langur monkeys that came to drink every evening burned up a lot of film and, since my target was tigers, that was somewhat frustrating, but now I look even at those frames (pages 109 and 111) and see a world that no human could otherwise see.

Every night I would dream of some way of capturing the essence of the tiger on film. I never did. The closest I came might be the one frame of Charger jumping across the cliff (page 97)—and he took that one himself.

Roy Toft (right) checks the angle on a camera trap which captured Charger on page 99.

THE EYES OF THE TIGER ARE THE BRIGHTEST

OF ANY ANIMAL ON EARTH.

AT DUSK...THEY BLAZE BACK THE AMBIENT LIGHT

WITH AWE-INSPIRING INTENSITY. IT WOULD BE

A TRAGEDY, AND A TERRIBLE DERELICTION OF DUTY,

IF WE ALLOWED THAT MAGICAL FIRE TO BURN OUT.

Arjan Singh

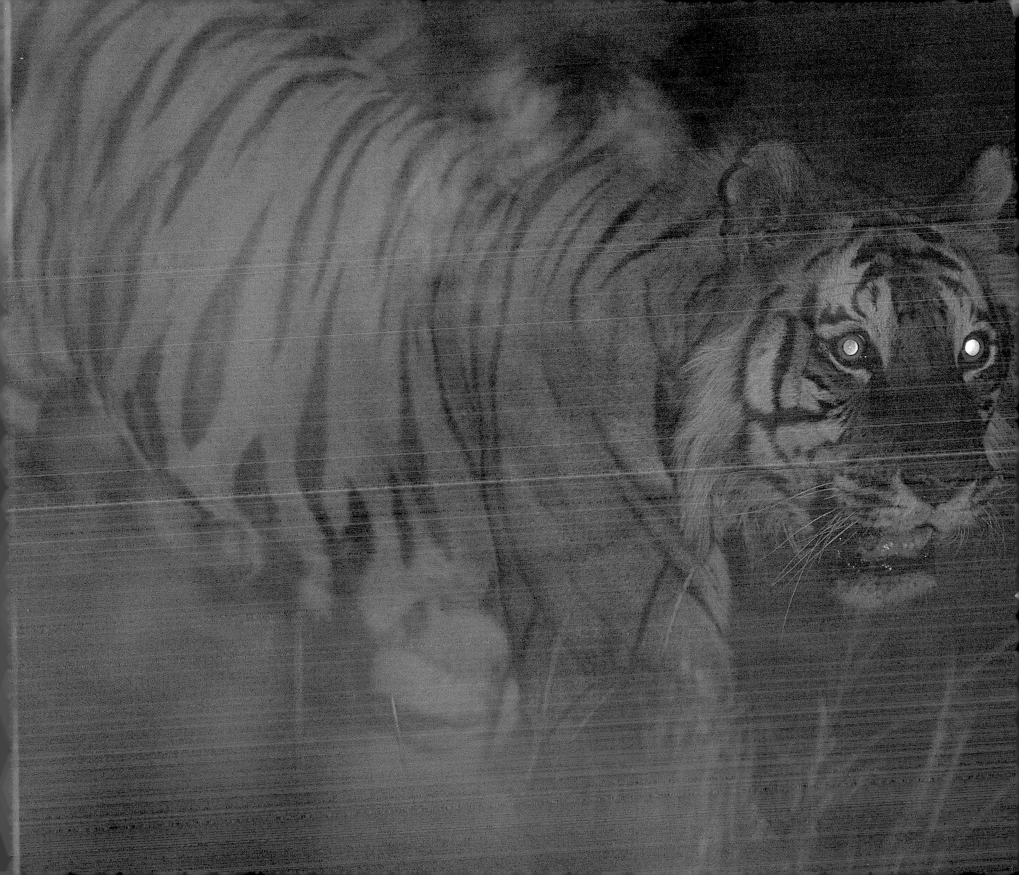

THE YEAR OF THE TIGER

By MICHAEL NICHOLS *and* GEOFFREY C. WARD

Published by THE NATIONAL GEOGRAPHIC SOCIETY
JOHN M. FAHEY, JR. *President and Chief Executive Officer*
GILBERT M. GROSVENOR *Chairman of the Board*
NINA D. HOFFMAN *Senior Vice President*

PREPARED BY THE BOOK DIVISION

WILLIAM R. GRAY *Vice President and Director*
CHARLES KOGOD *Assistant Director*
BARBARA A. PAYNE *Editorial Director and Managing Editor*
DAVID GRIFFIN *Design Director*

STAFF FOR THIS BOOK

LEAH BENDAVID-VAL *Editor*
KATE GLASSNER BRAINERD *Art Director*
PATRICE SILVERSTEIN *Text Editor*
JAMES B. ENZINNA *Researcher*
CARL MEHLER *Map Director*
JEHAN AZIZ *Map Production*
KEVIN G. CRAIG *Assistant Editor*
R. GARY COLBERT *Production Director*
RICHARD S. WAIN *Production Project Manager*
LEWIS R. BASSFORD *Production*
JANET A. DUSTIN *Illustrations Assistant*
PEGGY CANDORE, DALE-MARIE HERRING *Staff Assistants*

ROBERT M. POOLE *Consulting Editor*

MANUFACTURING AND QUALITY CONTROL

GEORGE V. WHITE *Director*
JOHN T. DUNN *Associate Director*
VINCENT P. RYAN *Manager*
JAMES J. SORENSEN *Budget Analyst*

Library of Congress Cataloging-in-Publication Data
Nichols, Michael.
 The year of the Tiger / Michael Nichols. Geoffrey C. Ward.
 p. cm.
 ISBN 0-7922-7377-X
 1. Tigers. 2. Tigers—Pictorial works. I. Ward, Geoffrey C.
 II. Title.
 QL737.C23N53 1998
 599.756—dc21 98-26376
 CIP